MICRO ART

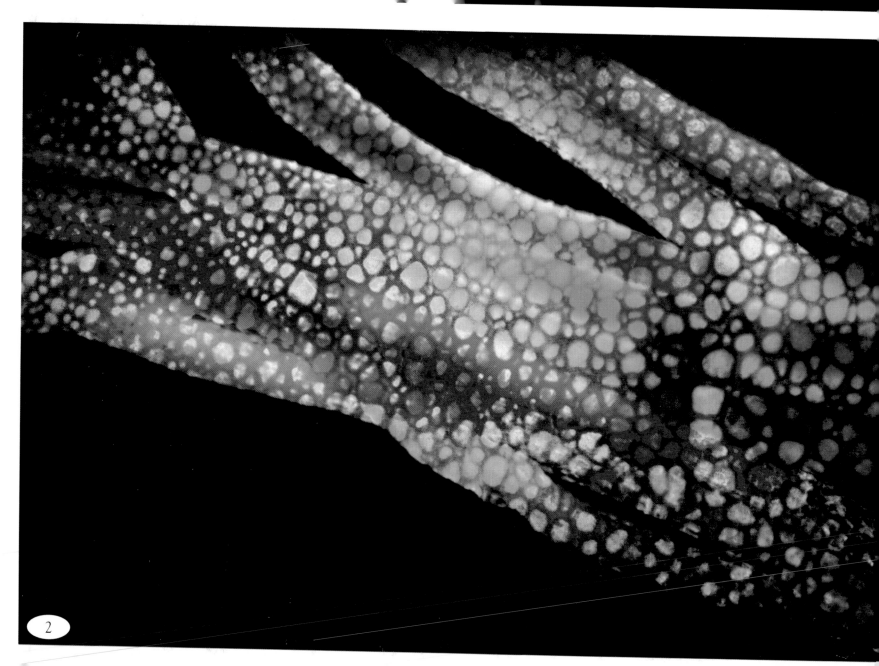

MICRO ART

Roberto Dabdoub

PELICAN PUBLISHING COMPANY

Gretna 2003

*The word "Pelican" and the depiction of a pelican are trademarks
of Pelican Publishing Company, Inc., and are registered
in the U.S. Patent and Trademark Office.*

Library of Congress Cataloging-in-Publication Data

Dabdoub, Roberto.
 Micro art / Roberto Dabdoub.
 p. cm.
Includes index.
 ISBN 1-58980-073-7 (acid-free paper)
 1. Photography, Artistic. 2. Photomicrography. I. Title.
 TR682 .D33 2002
 779'.092—dc21

2002007612

Printed in China

Published by Pelican Publishing Company, Inc.
1000 Burmaster Street, Gretna, Louisiana 70053

ACKNOWLEDGMENTS

This book is dedicated with love and gratitude to my wife, Mabel, for her love and devotion. Without her I would have nothing. My daughter Tirza, a visual-art professional, offered her designing insights for the project. My daughters Noreen and Chantal showed nothing but warmth and enthusiasm while I worked on the book. Thanks for enduring those long years while I was surrounded by lab equipment and microscopes.

Thanks to my mother, Luz Marina Sosa, schoolteacher and poet, who taught me so much about life with her writings.

Thanks to my parents-in-law, Dr. Ezequiel and Dulce Fraguela.

I give my deepest appreciation and gratitude to my friend Phil P. Jones, M.D., for sharing so much of his time and his resources.

Thanks to my publisher, Dr. Milburn Calhoun, Editor in Chief Nina Kooij, and all the diligent staff at Pelican Publishing Company, who made it all possible.

Thanks to friends and family who have given support and feedback of various kinds. They include, in alphabetical order, Luis A. Bernhard, Rosaleda Cohen, Leonard Palmisano, J.D., Om Prakash, Ph.D., and Edward Randrup, M.D.

I also thank writers and publicists Skip Brown, Wade Byrd, Sandra Cordray, Gina Cortez, Meg Farris, Luba Glade, Thomas Gore, Bill Grady, Peggy Laborde, Jerry Liddell, Maria Ward McIntosh, John Maher, Bob Marye, Norma de Moncada, Merrick Murdock, Margarita Nodarse, Carole Parks, Eric Paulsen, Billy Pena, Susan Polowceuk, Magaly Rubiera, John Snell, Matthew Teague, Fletcher Thorne-Thomsen, Chris Waddington, Bob Warren, and Charles Zewe. I acknowledge the help of the late Terry P. Smith and also of New Orleans Museum of Art Director E. John Bullard and curators Nancy Barrett, Tina Freeman, and Steven Maklansky.

Last but certainly not least, I am indebted to my friends, acquaintances, and colleagues at Ochsner Clinic Foundation in Louisiana, who have given me their love and support.

I dedicate this book also to the memories of Guillermo Carrera, M.D., William Rickoll, Jr., Alton Ochsner, Sr., M.D., Max Heidell, and my grandmother, (Choncita) Encarnacion de Sosa.

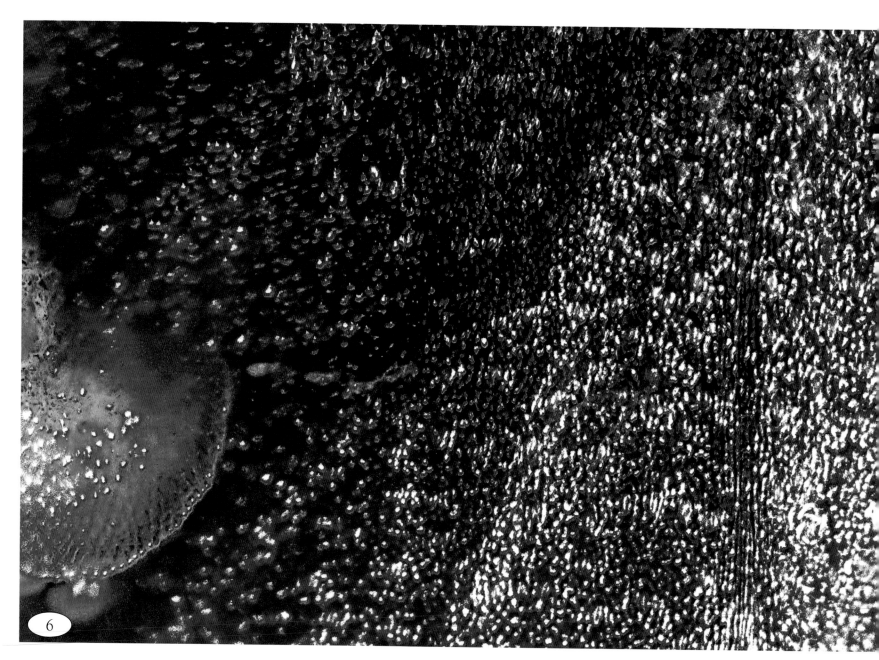
6

INTRODUCTION

Discover the Small World of Photomicrography: Art Under the Microscope

Many people don't realize there is so much beauty under the microscope. How many of them would believe there is beauty in cholesterol or in an onion skin? When viewed with the eye of an artist and captured by the camera, these objects become portals to an enchanted landscape. I never took these things for granted. I knew there were beautiful patterns in nature, and under the microscope you can focus on and isolate them. A drop of cholesterol crystallizes into a field of golden sprigs. The DNA strands of life become glittering strings exploding with color. Uric acid is a green field populated by delicate white flowers.

My passion for photomicrography dates back to when I was a schoolboy. I used to wander in the mountains of Honduras with my camera trying to capture, in black and white, driftwood and eroded mud flats after a flood. Here in New Orleans, my other hometown, I spent one year documenting the moving waters of the Mississippi River. Later, when I became a scientist and moved to the business of studying chromosomes, the genetic picture life, I continued searching for beauty, at the molecular level.

Isolating and capturing the images on film is time consuming and labor intensive. It all begins with a sample—for example, mold. The sample is treated with a special medium, centrifuged to remove waste material, placed on a slide, and viewed under the microscope.

When I find something that is visually exciting, I determine which way to capture it. It is almost like creating a painting. I add few filters to heighten intensity, change the lighting, and, like magic, my microscope becomes a window on a vast landscape.

The Procedure

Photomicrography often requires instruments and techniques not frequently used in traditional photography, and learning how to photograph through a microscope is not an easy task. Many of the procedures, such as lighting, focusing, exposing, and even locating the tiny area to be photographed, are much more complex than in ordinary camera work.

An intense beam of light is used to illuminate transparent objects from below. This procedure, known as bright-field illumination, is widely used in the clinical lab for straightforward tissue observations. However, the diversity of subjects also calls for the mastery of other types of lighting: dark field, phase contrast, interference contrast, epifluorescent, and cross-polarization. Under polarized light, cholesterol, uric-acid crystals, and some ancient fossils light up in a fantasy of swirling colors. Many fluids show stunning characteristics under this type of illumination.

What I found most interesting about my discoveries, in some of the crystal formations, was not the patterns they form but the

energy from which they originate. For example, if you see snow crystals, you don't see the patterns at first, but they are there. Studying nature at this molecular level is like looking at worlds within worlds. Surprisingly, many of the patterns you find in the microcosm are very similar to the patterns you find in the visible world, all around us. It makes you begin speculating about the form of the universe and creation of the planet.

In 1977, I created a high-frequency generator-oscillator in a compound microscope. My device was used to capture many of the elusive images that have mystified scientists around the world. When my work first appeared on CNN and circulated through the news wires, I received hundreds of supporting letters from doctors and scientists across the country. To this day, there is very little scientific explanation for some of the photographs. Nonetheless, the images are intriguingly beautiful.

I feel uncomfortable talking about beauty under the microscope, since I am really trained to find problems, not beauty. When I work with colleagues, we make a diagnosis and do nothing else. We find the problem and we're finished. Perhaps that narrowness explains why interest in science is declining among children. I truly believe that the microscope is a great tool to teach kids to celebrate complexities and how to express their feelings with art. It can give students a new incentive to look at science as I do. When you have a rounded knowledge of many things, you can be more efficient when you focus on one thing. I know that when I draw a portrait, or play classical music on my violin, another of my avocations, my imagination is opened. That is the most important thing in any field or any art. People often forget that, despite all the scientific equipment, medicine is an art.

The Necktie Story

When I was working on a research project to identify specific human genes using fluorescent probes, I discovered interesting patterns that reminded me of necktie designs I had seen at the mall. These patterns had a definite scientific meaning for us at the lab, but I thought they could also convey a message and be enjoyed as an emotional experience by everyone. The images were spectacular, often reminiscent of *Star Wars* settings, and I felt they needed to be displayed outside our lab.

First, I wanted to excite kids about science, and I thought showing the beautiful side of medicine was a good way to accomplish this. Also, my images had a meaning, while those at the mall were pretty, but meaningless. At that time, this concept was fresh to the fashion industry and opened many designing possibilities. The big question for me was, who will want to give their dads diseases to hang around their necks?

Fascinated by my first discoveries, I began experimenting on my own time, focusing on other subjects. Some were mundane, yes, but beautiful. I looked at bugs' wings, red wine, coffee, sugar, Mardi Gras beads, interferon (a cancer drug), and many tissue samples, including the cloth from a 3,000-year-old mummy. After long negotiations, the line "Micro Shots" was registered by one of the largest tie manufacturers in the world. My name and the description of the product were written on the back of every necktie made. The neckwear was sold under designer names such as Jesuis, Oscar de la Renta, 7th Avenue, and Wembley. I donated all of my profits to AIDS and cancer research.

Making the Switch from Film to Digital

When I worked at the *New Orleans Times-Picayune* as a writer, I used a gigantic camera for some of my photo assignments. The 8x10 and 11x14 negatives can definitely beat any 35mm or digital camera in the market today. I was fascinated with sharp images. I used to carry a magnifying glass in my pocket, just to look at dust on photographs. I was definitely sick!

The camera's wooden box was so heavy and bulky that, one time, I had to hire a buggy in order to move around the French Quarter. On another memorable occasion, I used the camera to make a portrait study of former boxing champion Muhammad Ali. Ali held my daughter so I could load the film. He became a little guarded when he saw me opening the giant bellows. Maybe he felt threatened by the camera. Another time, I was photographing the Mississippi River spillway when a patrol helicopter began hovering overhead. The crew must have been wondering what I was doing with a cannonlike device. And that was before September 11, 2001. Soon after that incident, I gave up on the wooden box and traded it for a more practical piece of equipment.

For photomicrography, I currently use 35mm, 120mm, and digital cameras. To couple the nondigital boxes with the microscope, I use many dedicated commercial adapters. With the digital cameras, I use custom-made mounts. An optizoon 0.8x-2.0x attachment from Nikon helps provide better control of the optics. As with all digital cameras, field of view has to be compromised, since the CCD imager is smaller than a 35mm frame of film, and the microscope magnification factor reduces the view considerably. I use a special 6.5x eyepiece, rather than the typical 10x, to compensate for this magnification factor. I use a variety of instruments to create many of my images, such as Kodak, Polaroid, Leitz, Leica, Zeiss, Nikon, Olympus, and Hasselblad equipment.

In 1978, I presented in California one of the first scientific papers in the U.S. demonstrating the effectiveness of digital technology in photomicrography. As much as I love film, I believe that digital imaging technology is producing some pretty amazing results. I am transferring many of my photomicrographs and other work to this new medium. My black and white portrait study of North American Indians, the photomicrography project I did with my daughters for *National Geographic*, and some other photographs, such as my work now in the collection of the New Orleans Museum of Art, are being digitized with an ultra-high-resolution scanner.

I think of my images as more than decorative. They are portraits of things that thrive in a world full of mystery and divine power. I wish to share here my reverence for the infinitesimal and give you a glimpse into these tiny universes.

The Index

I present the images here, uninterrupted, for your pure enjoyment and wonder. When you wish to know what you are seeing, please turn to the index at the back of the book and look up the page number. As you play this game, you will be surprised to learn the identities of these glorious visions that are hidden everywhere in the world around us.

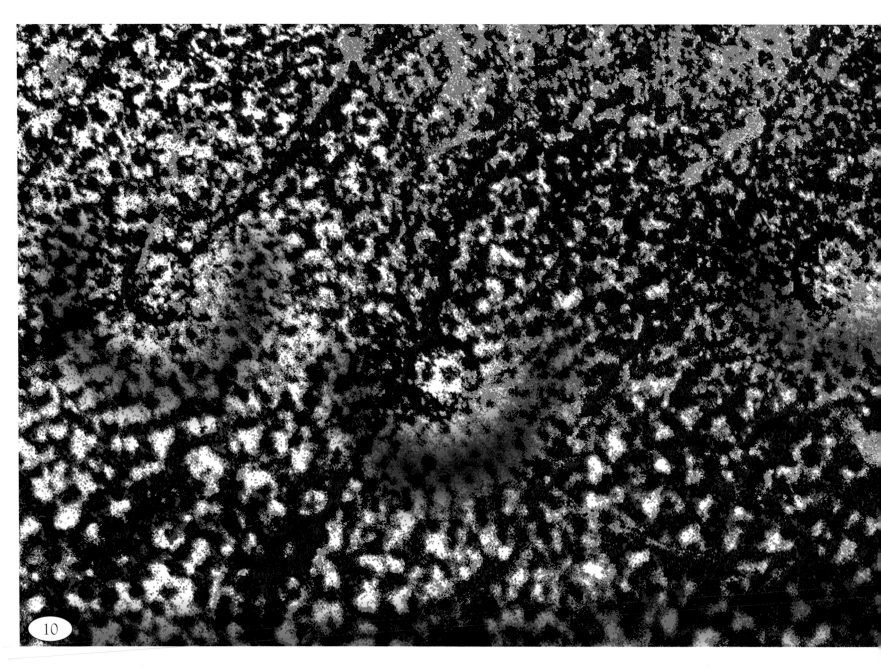

MICRO ART

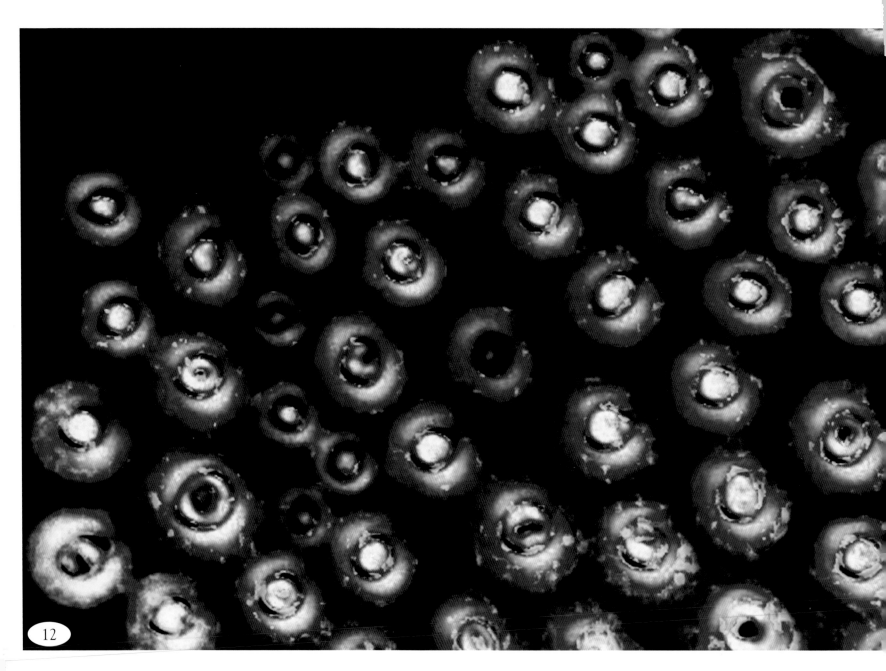

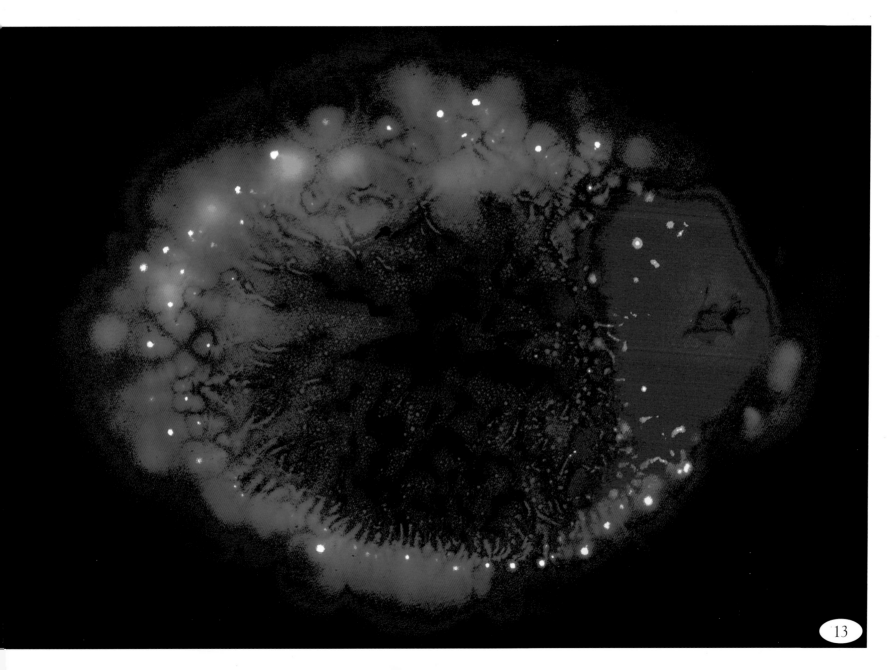

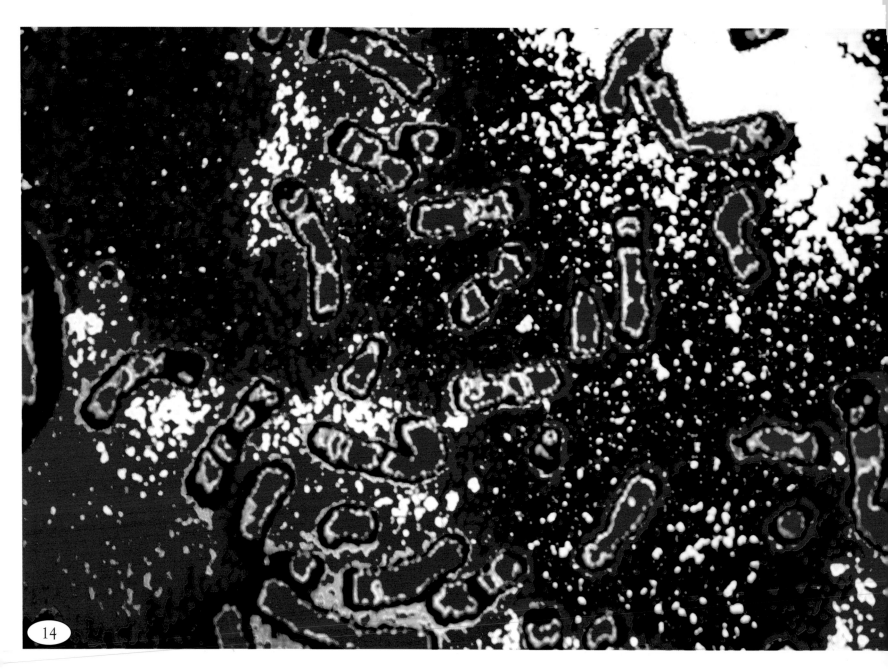

14

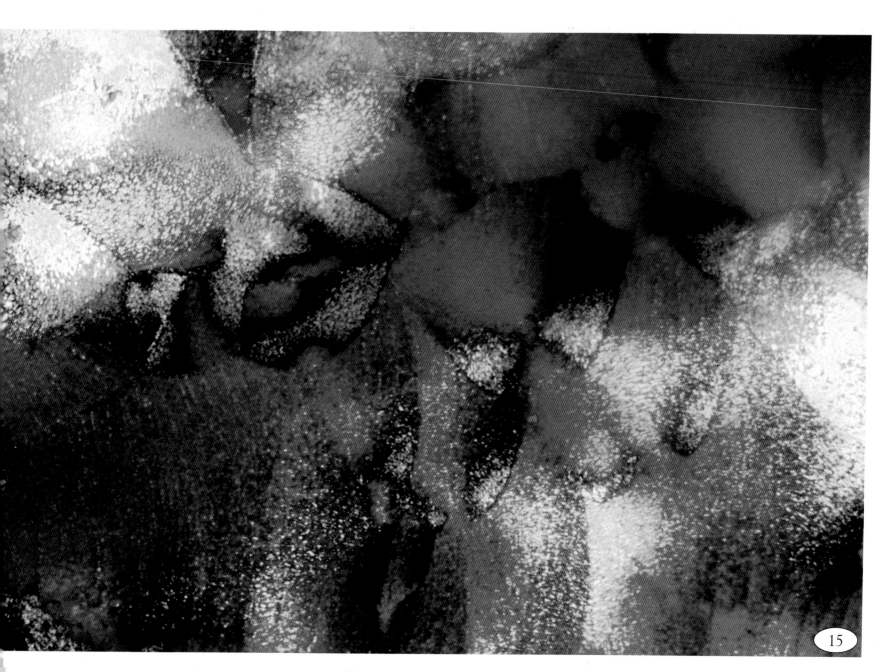

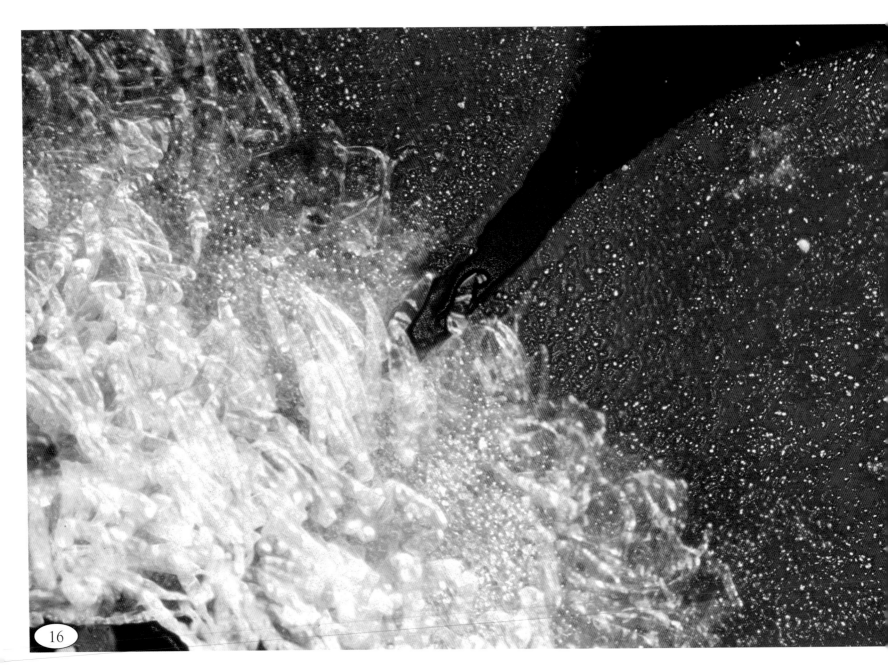

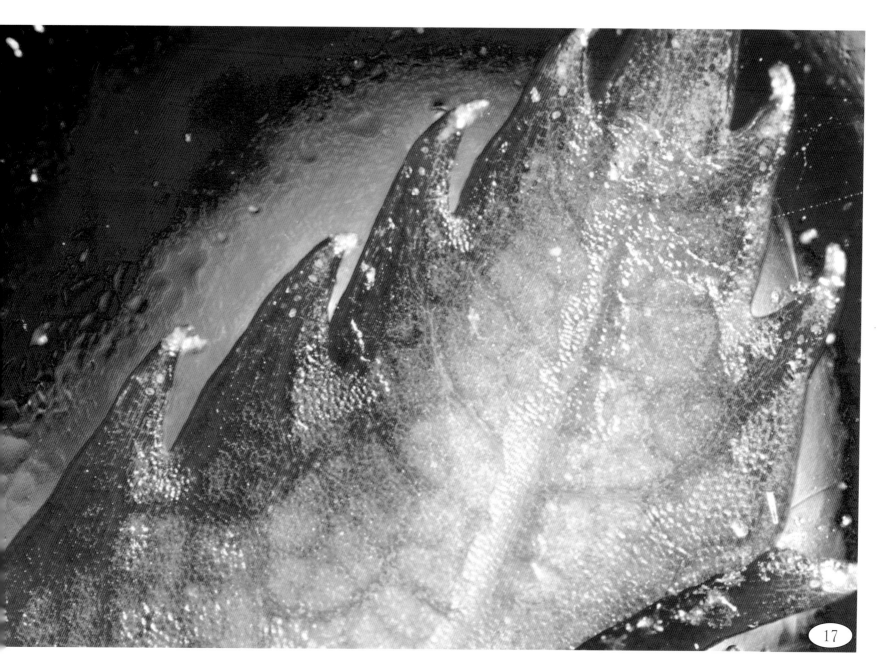

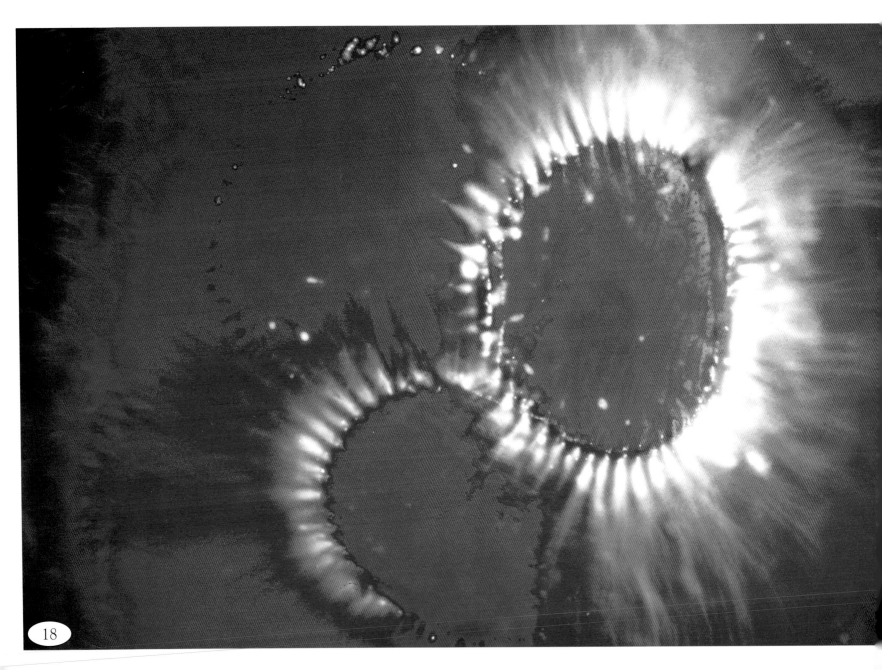

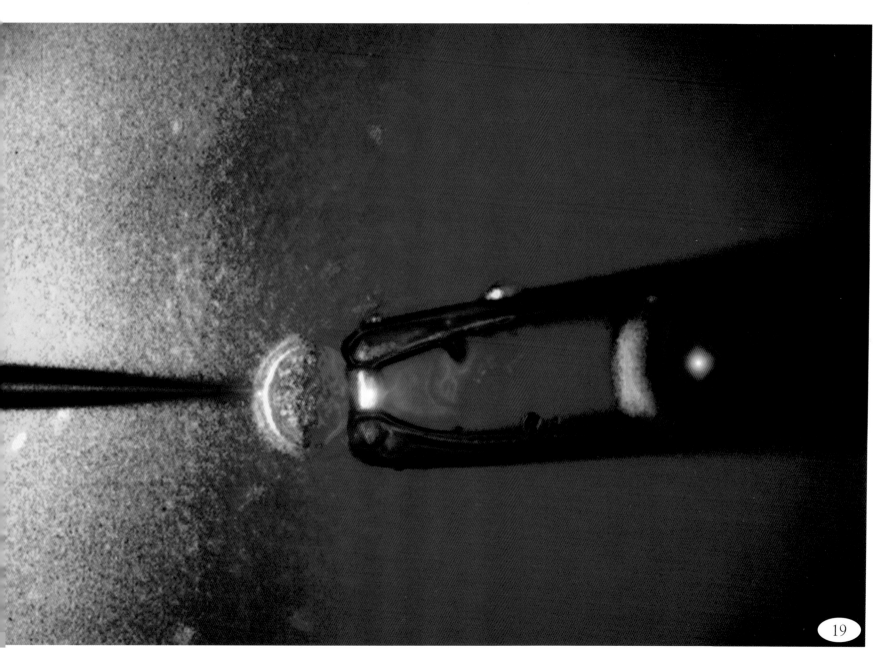

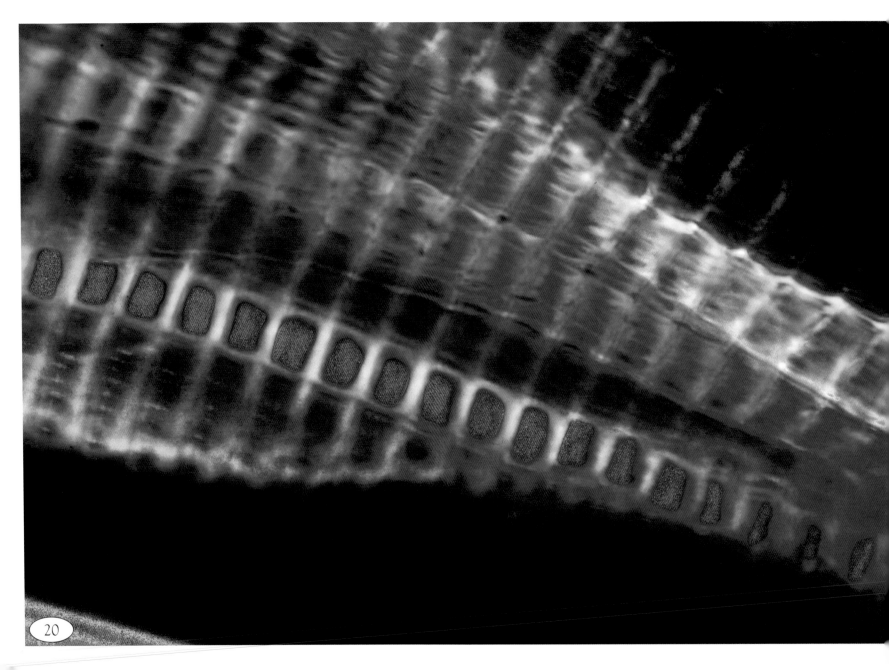

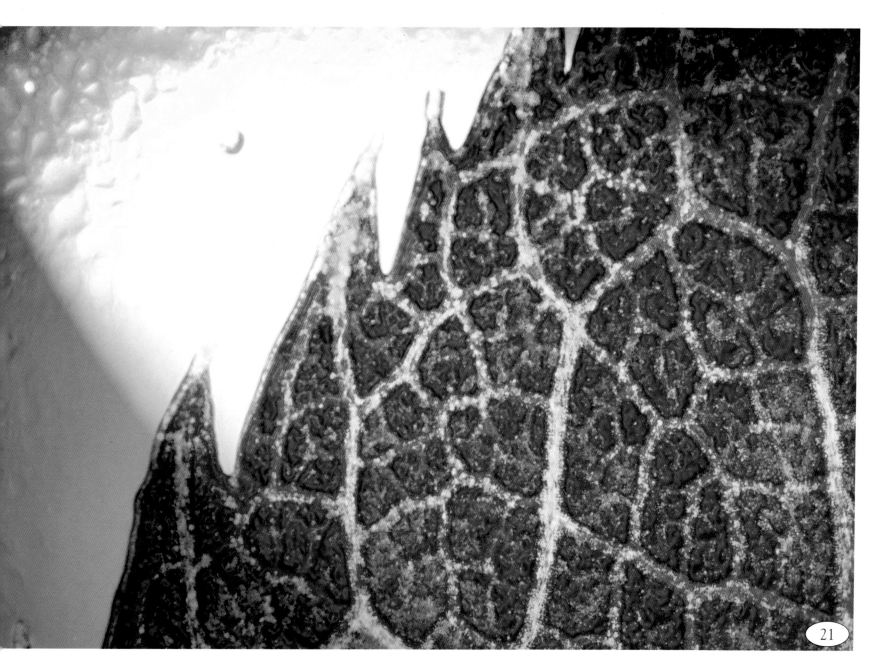

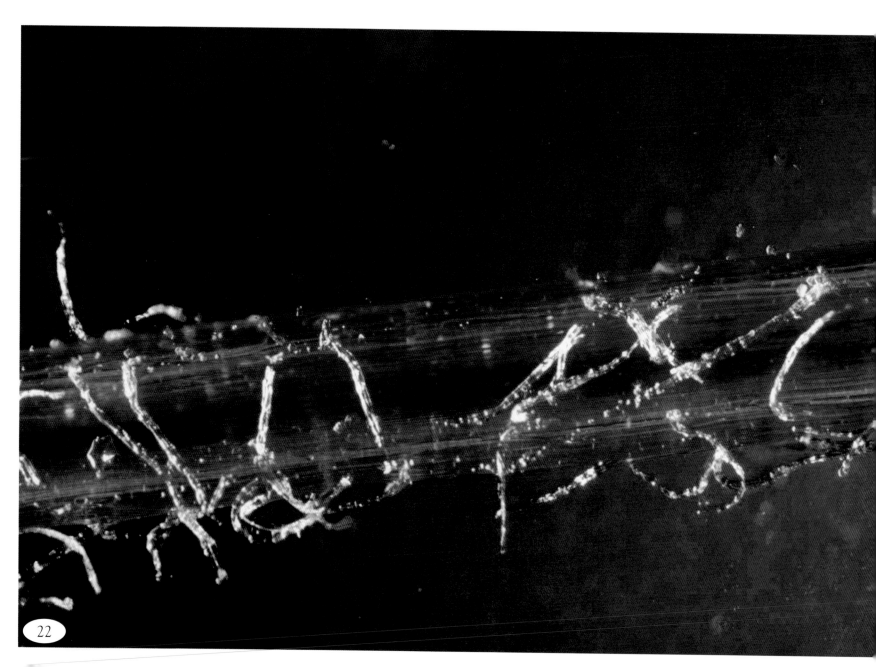

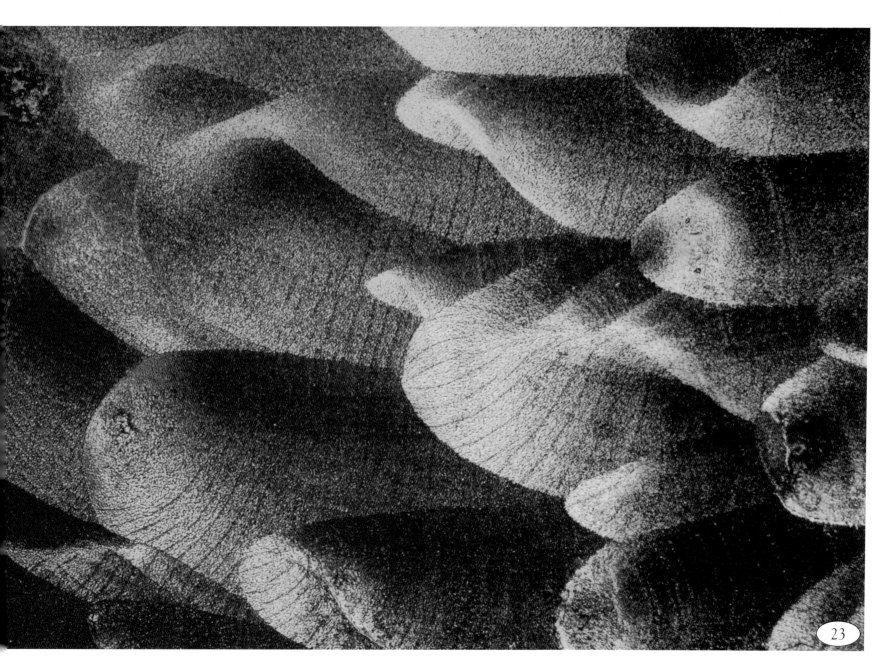

23

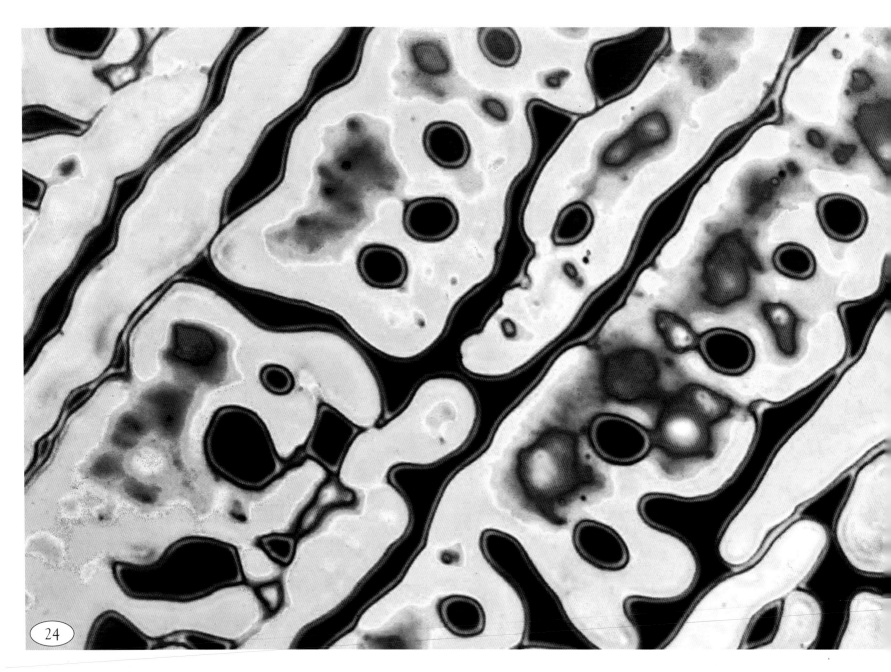

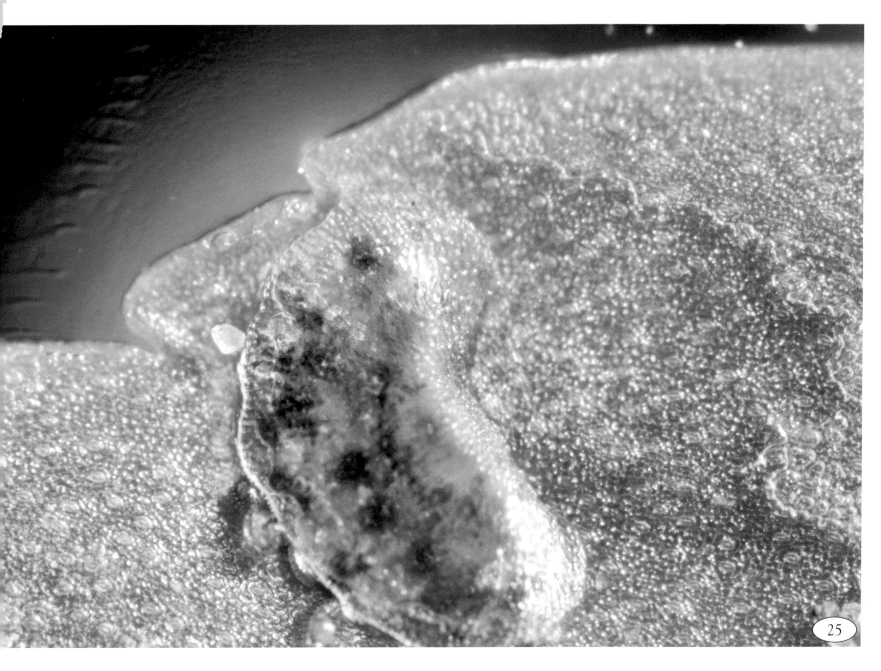

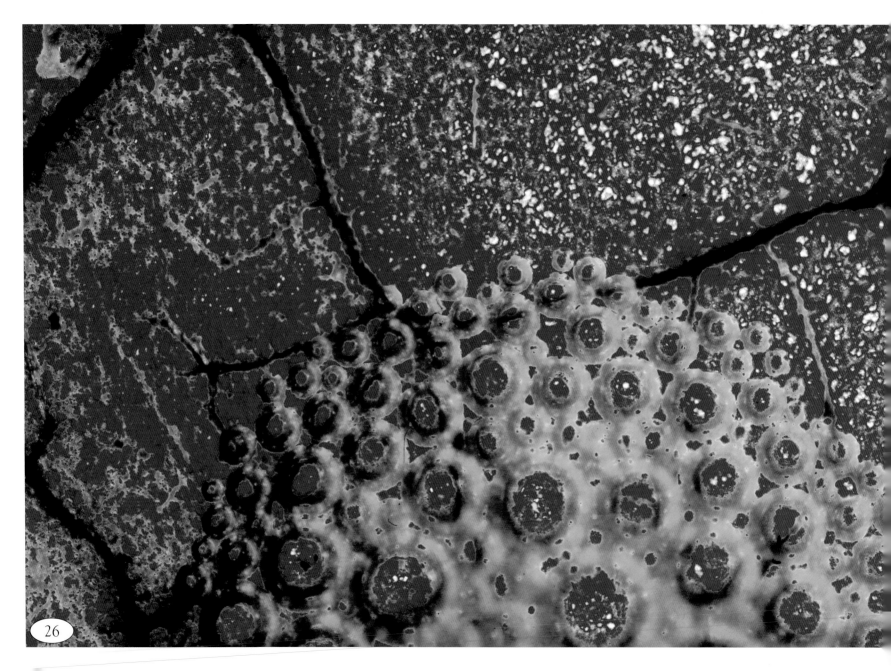

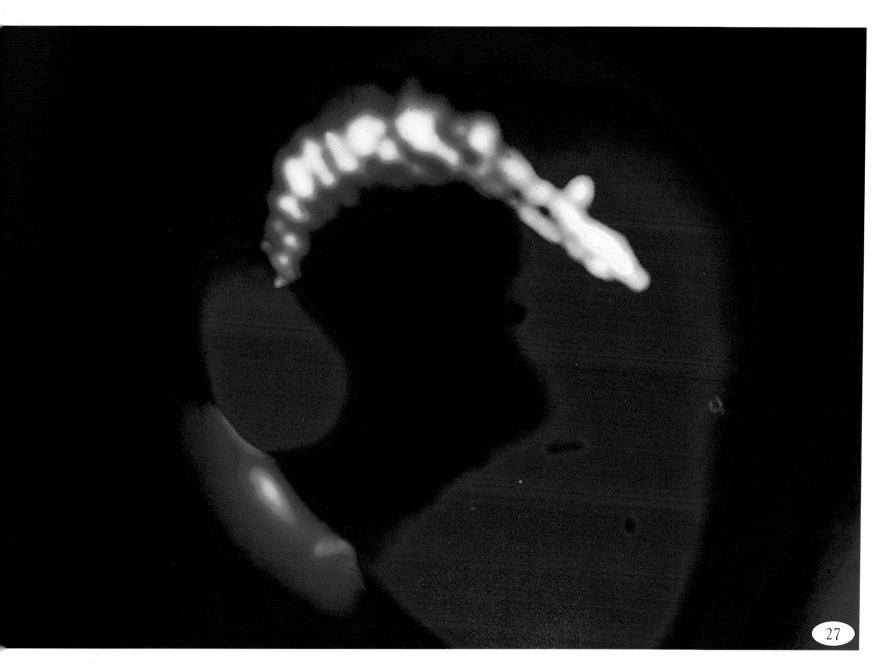

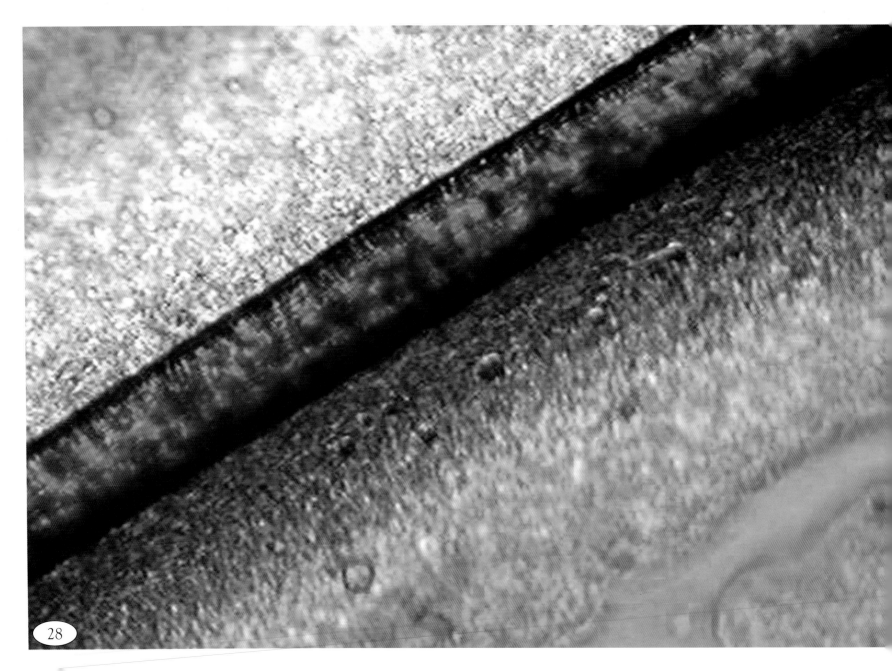

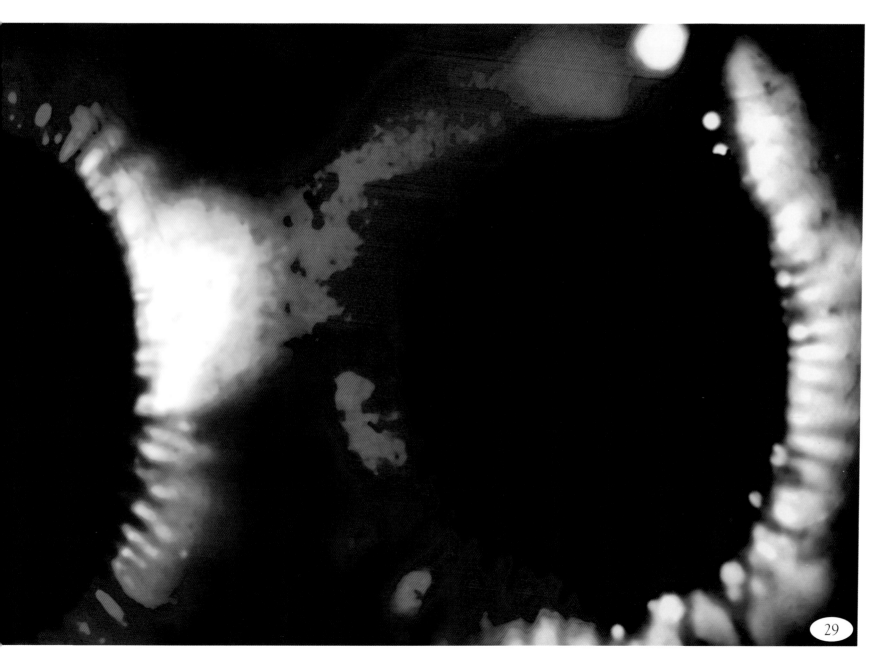

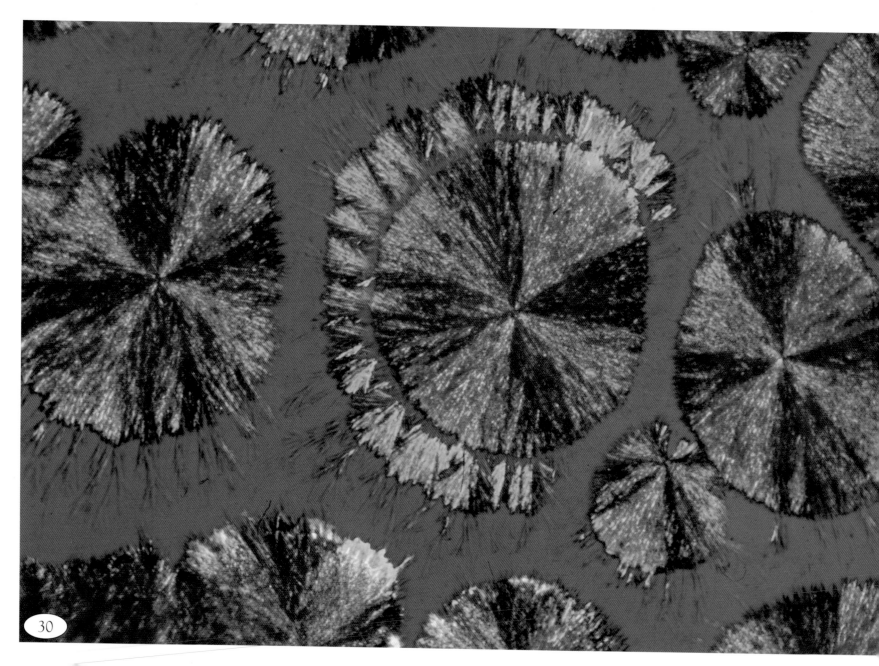

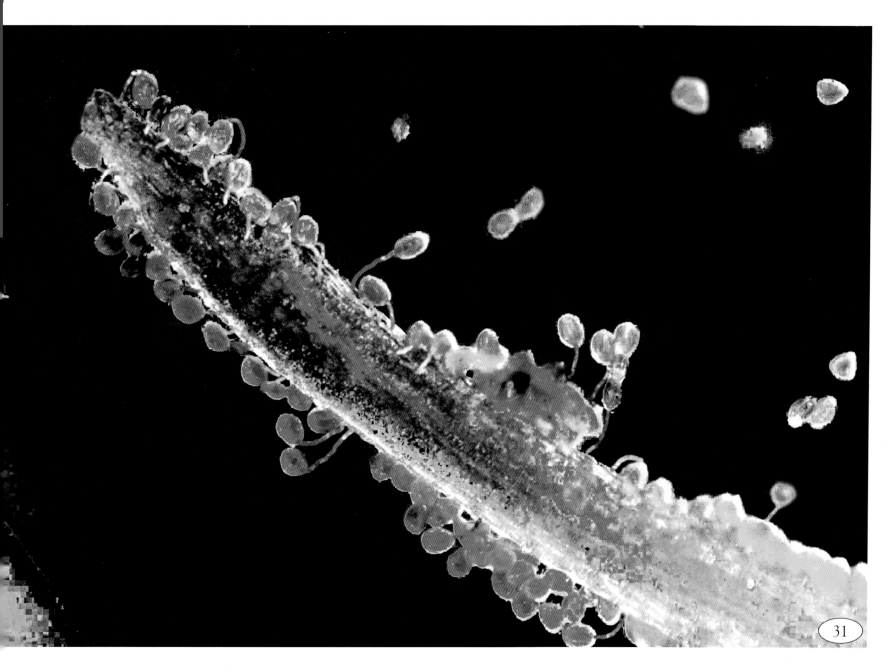

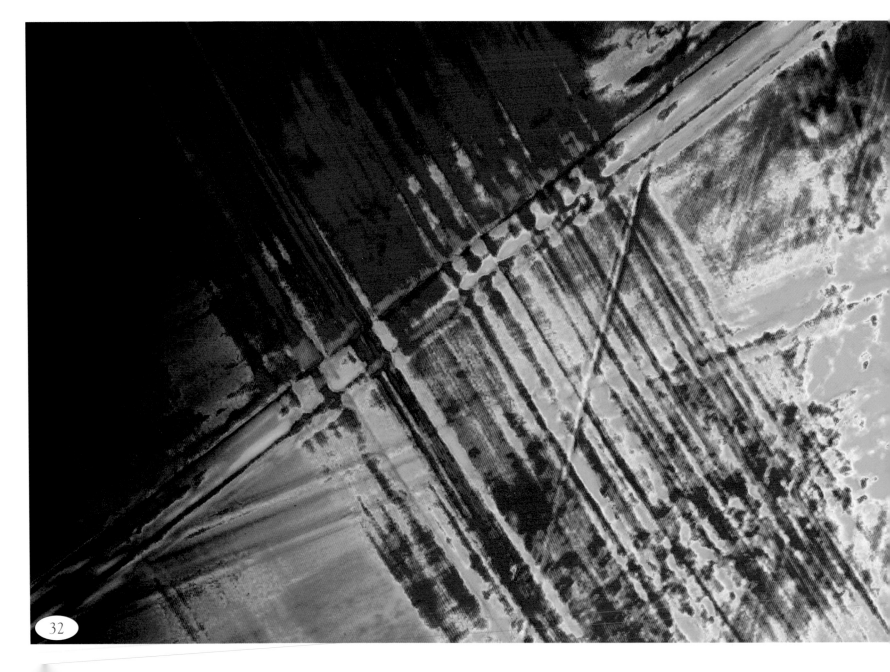

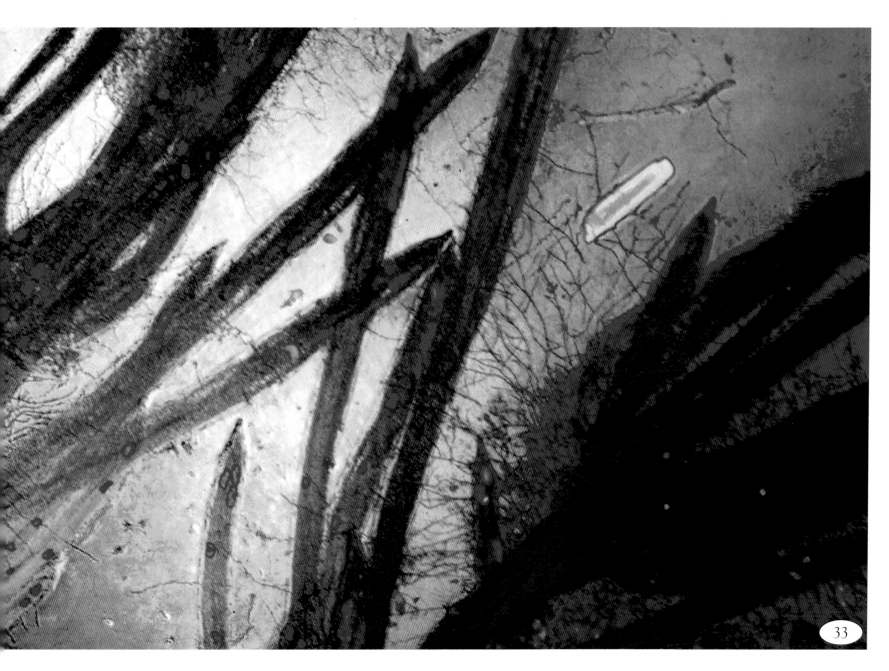

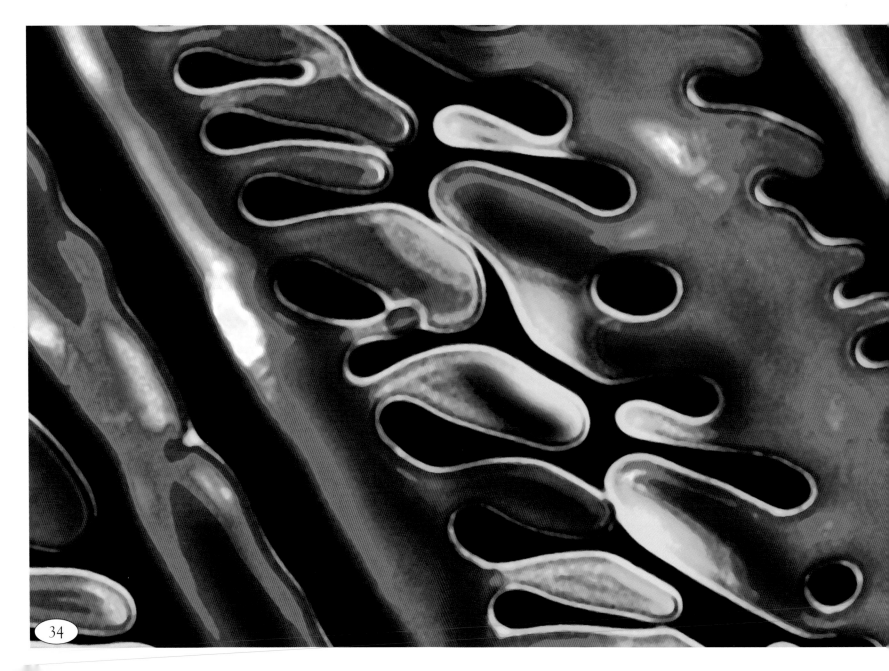

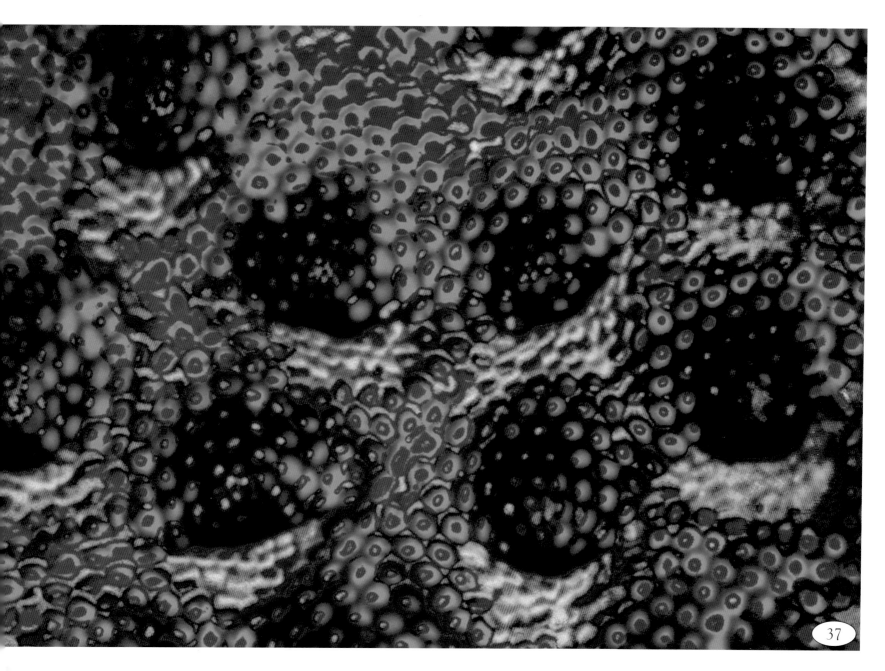

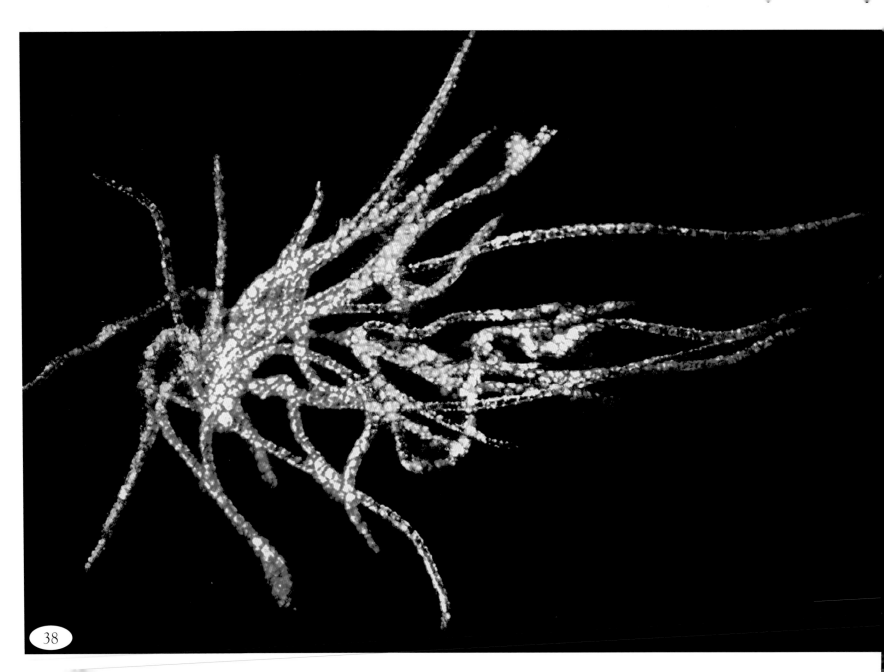

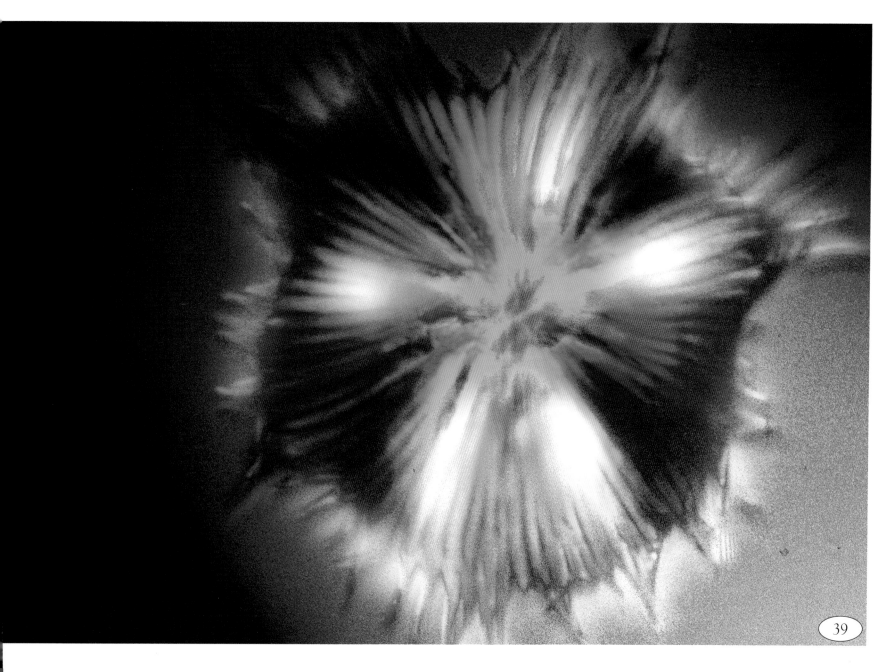

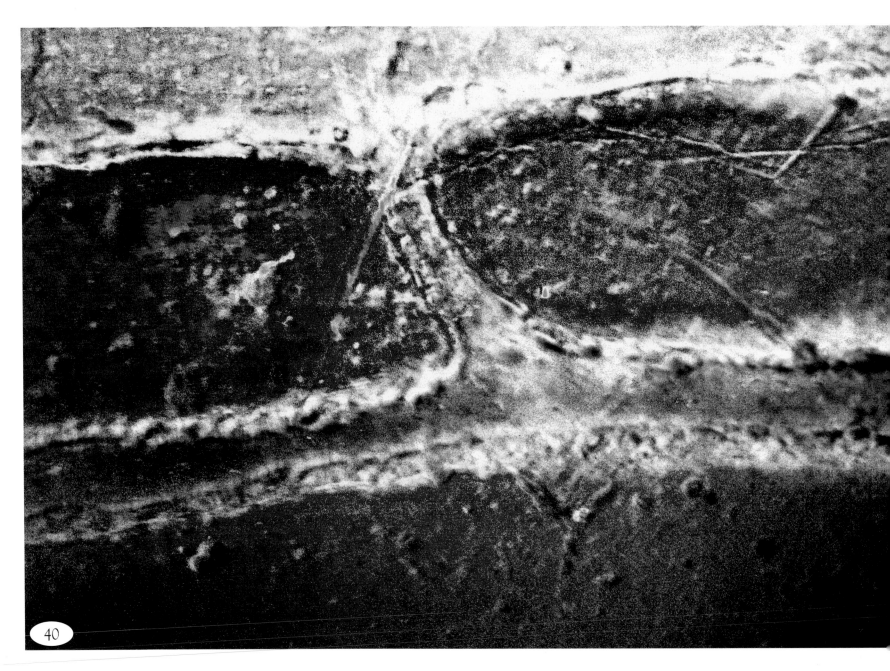

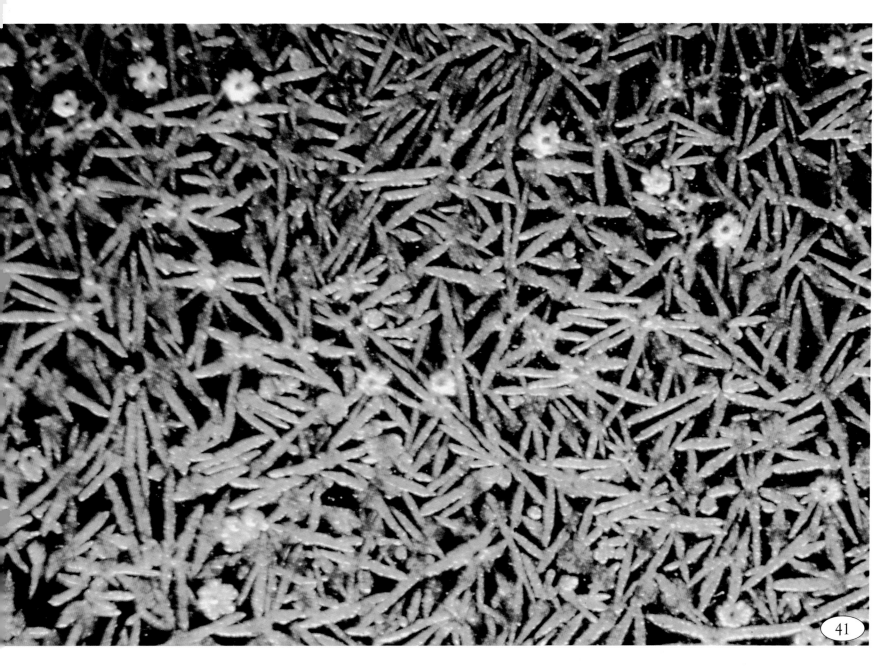

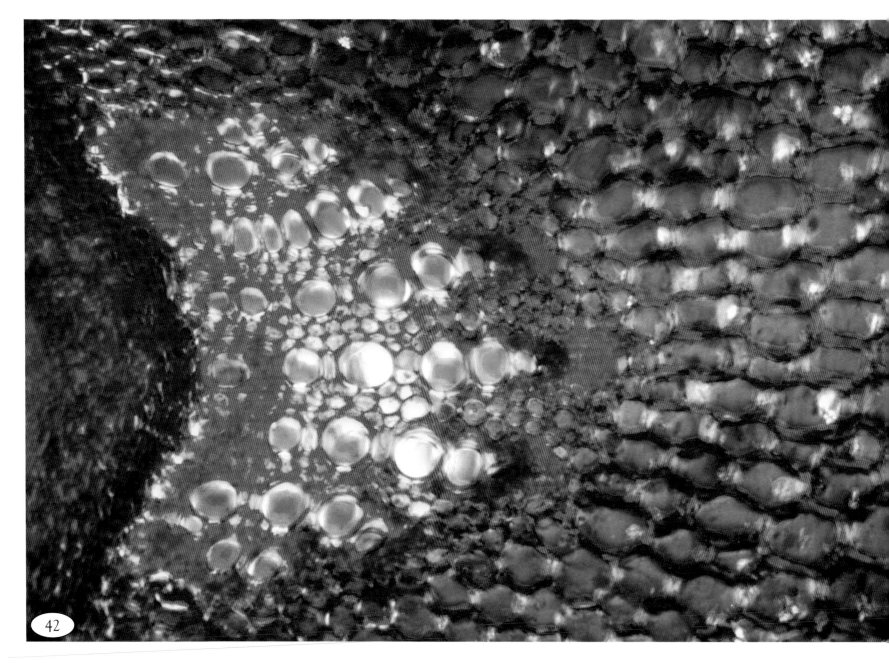

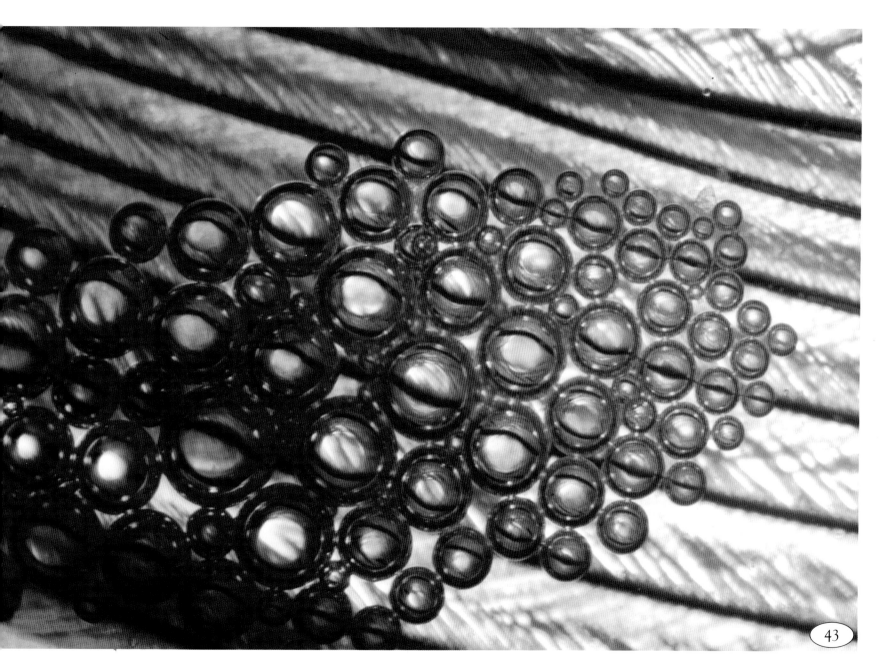

43

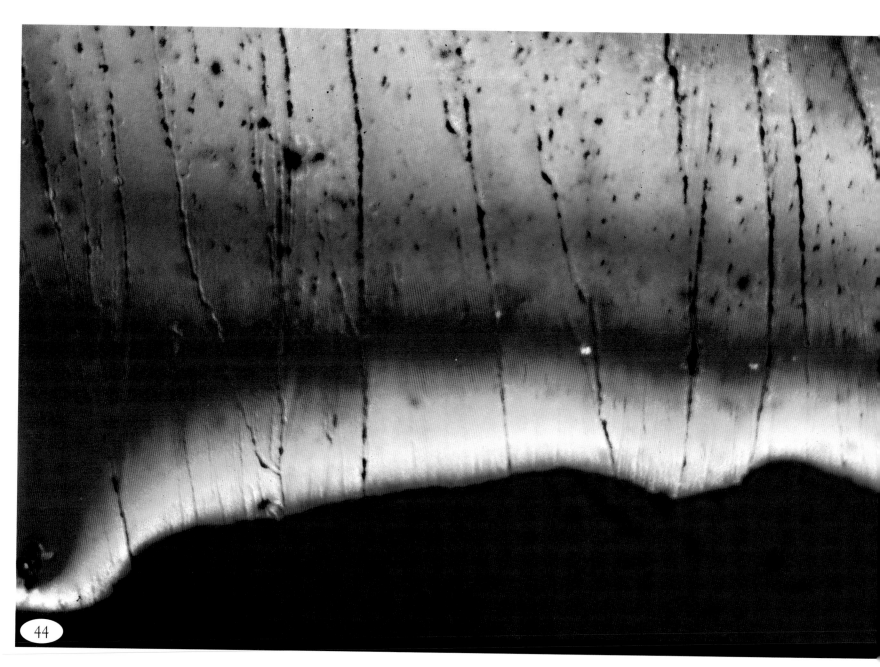

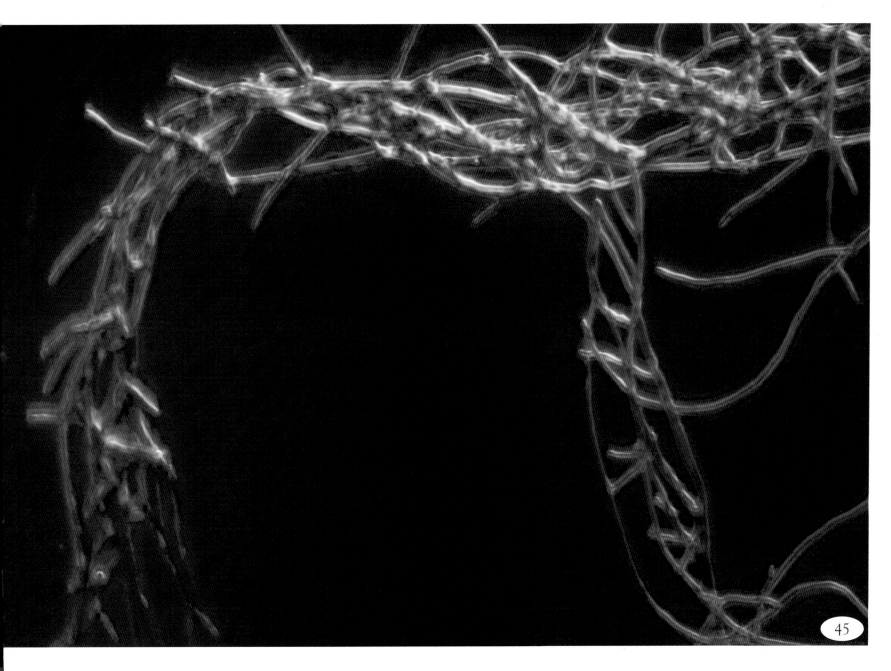

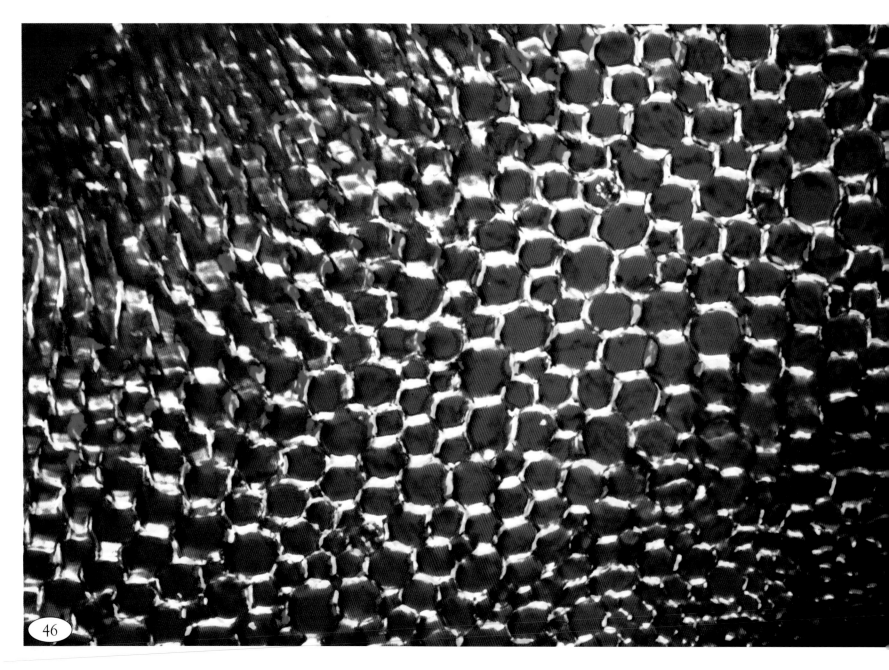

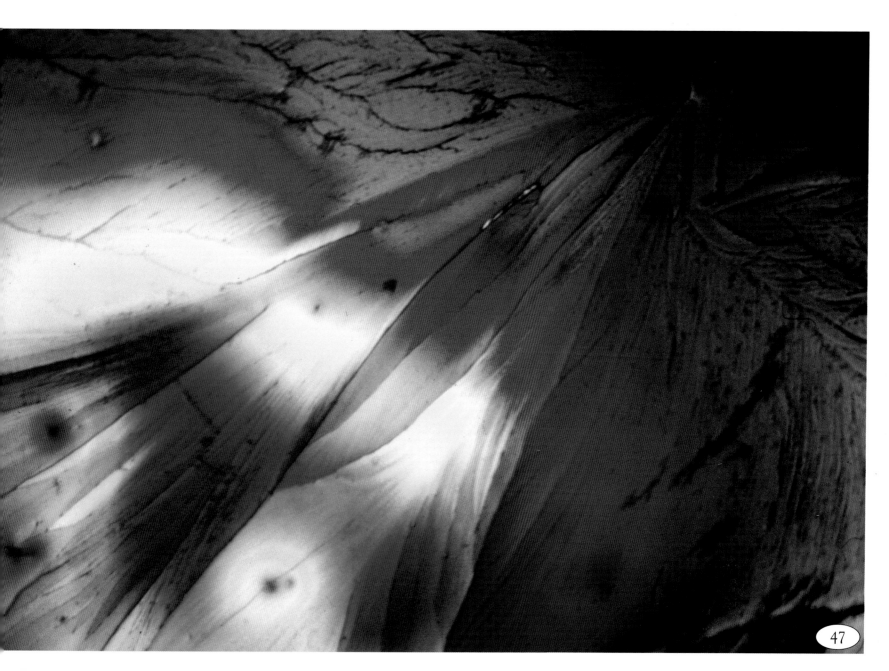

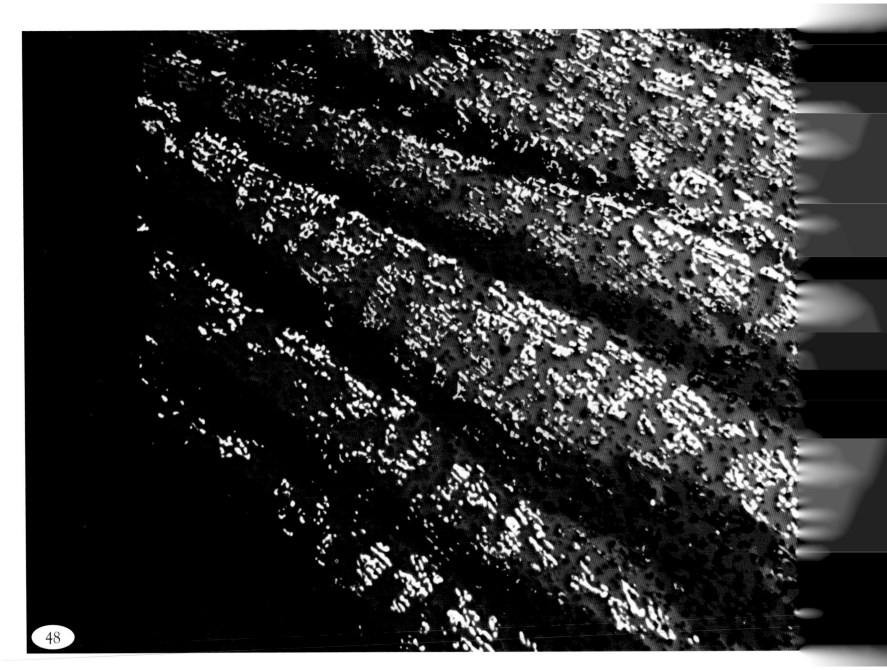

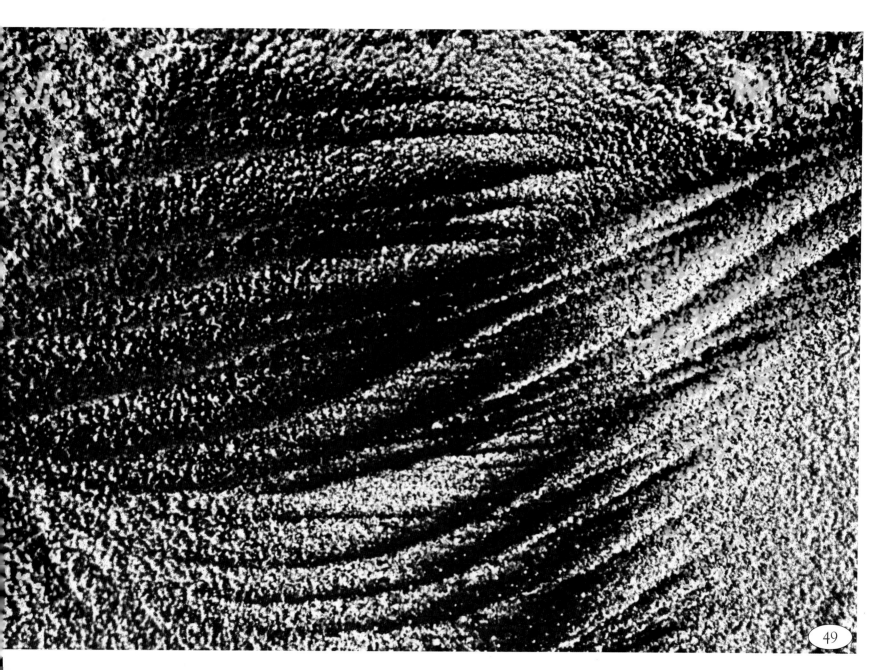

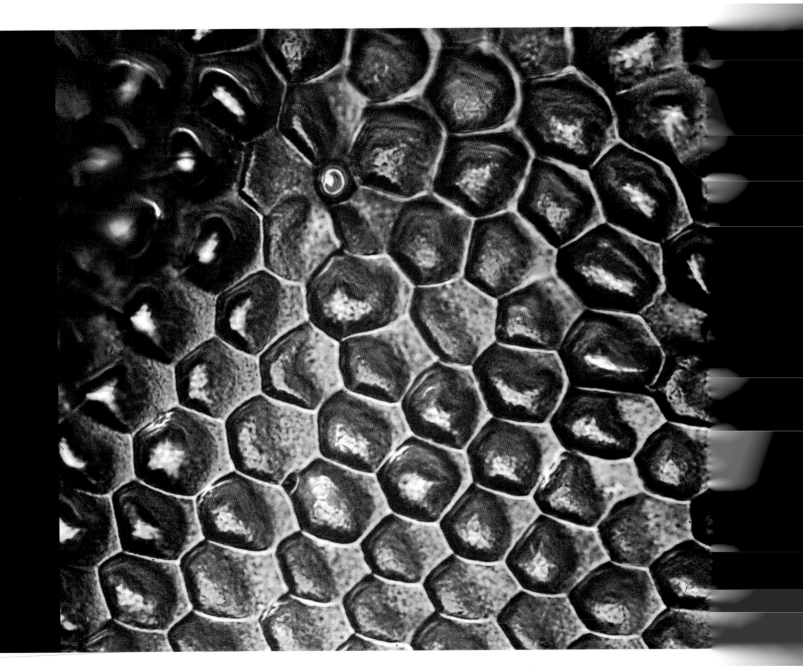

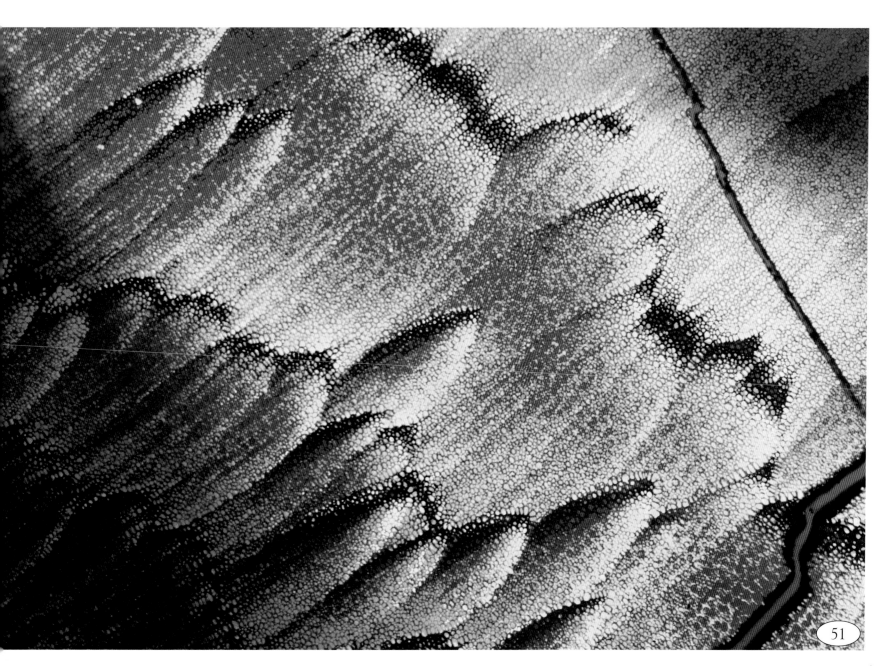

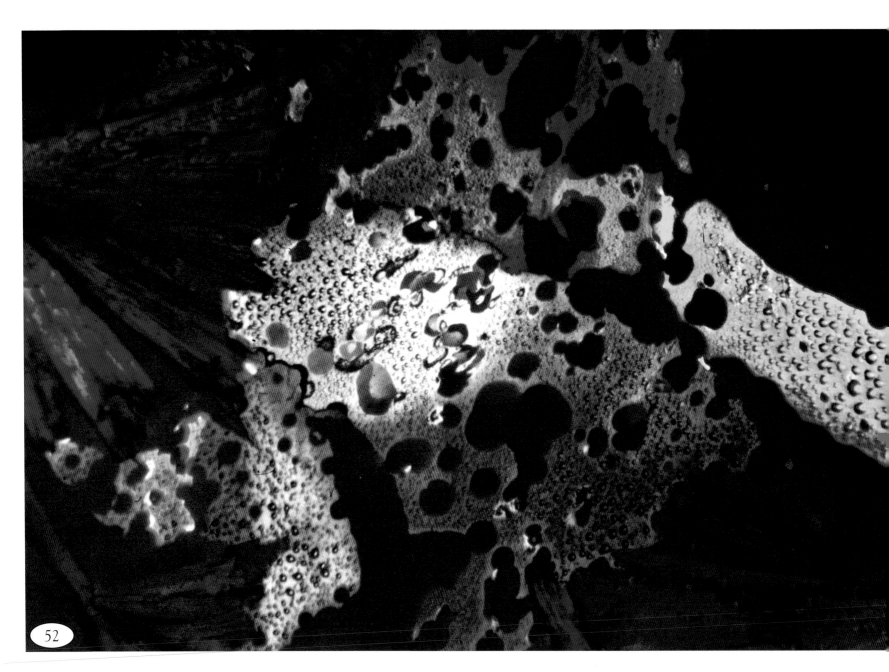

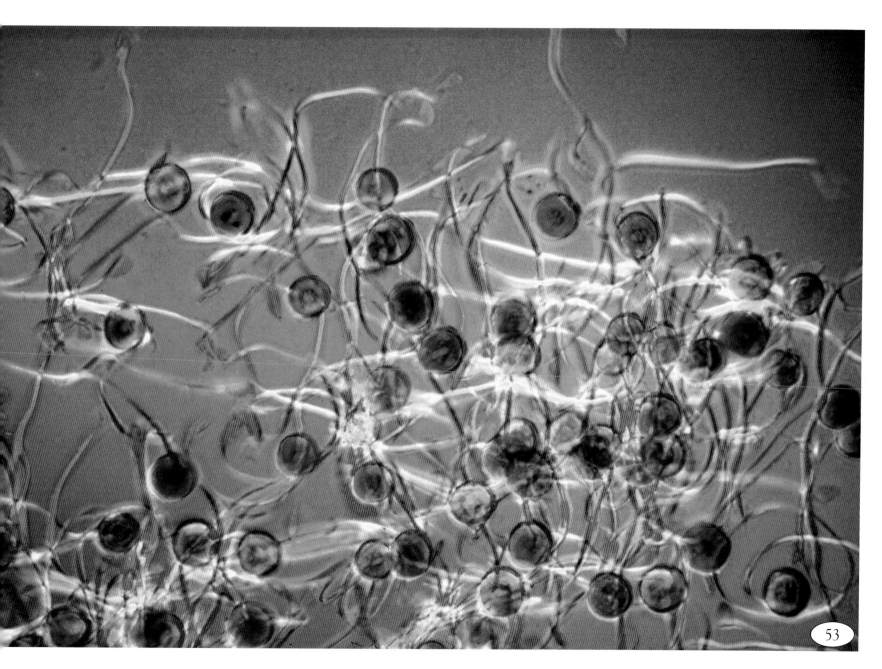

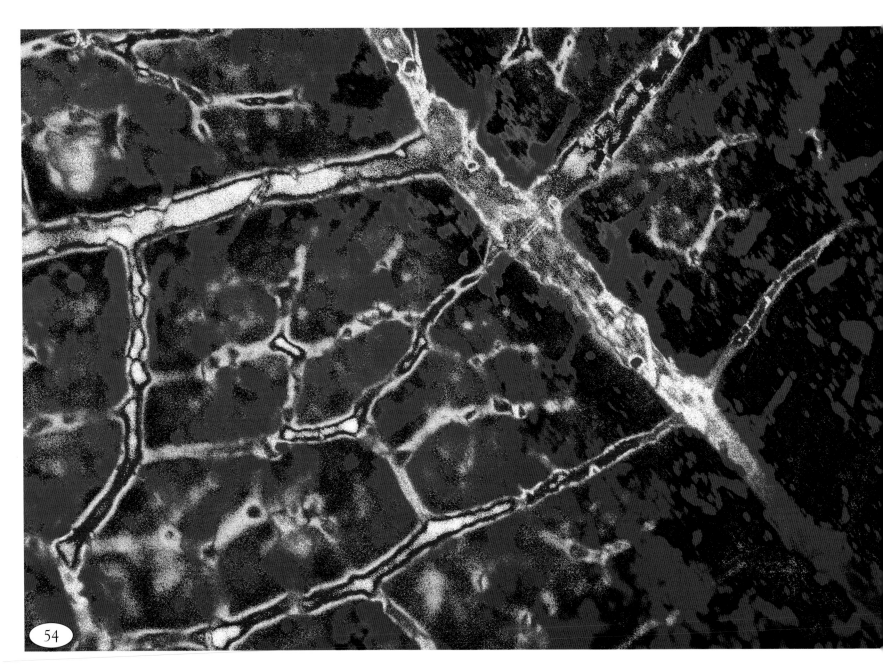

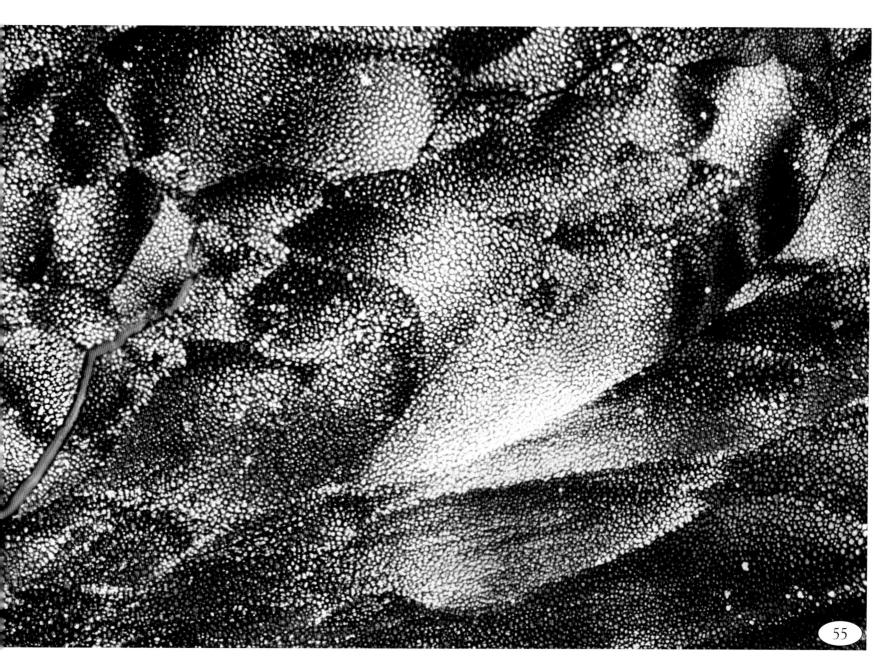

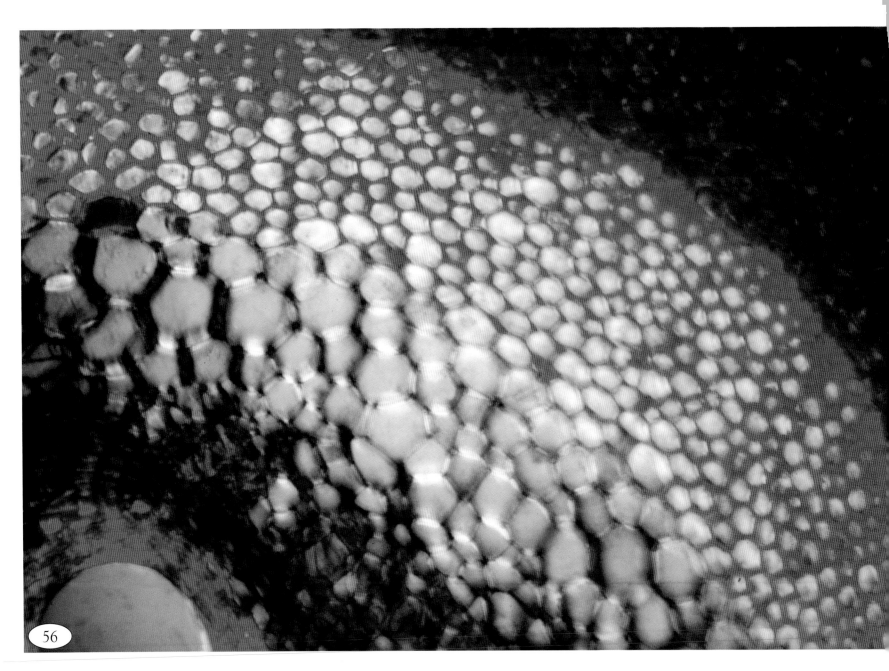

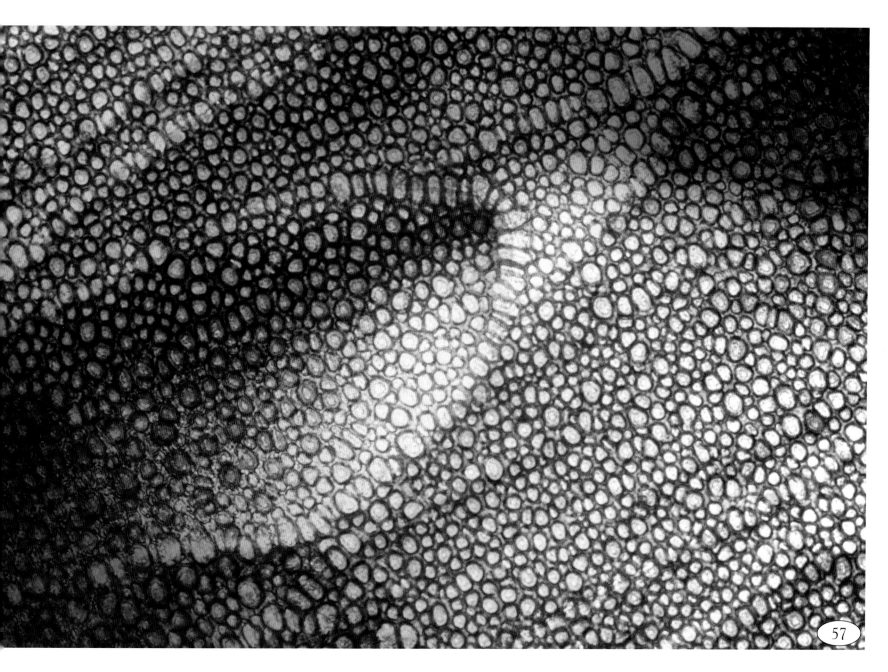

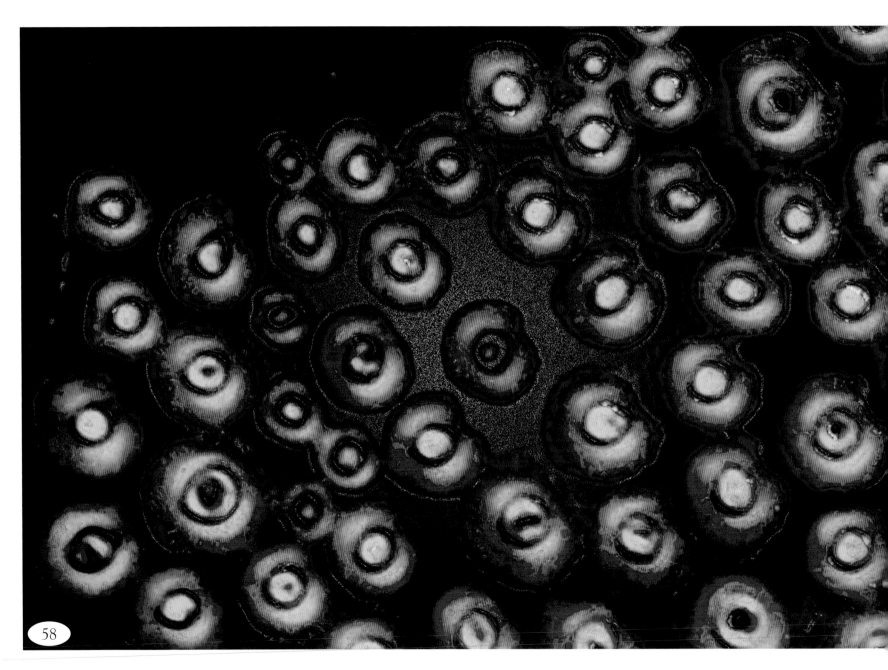

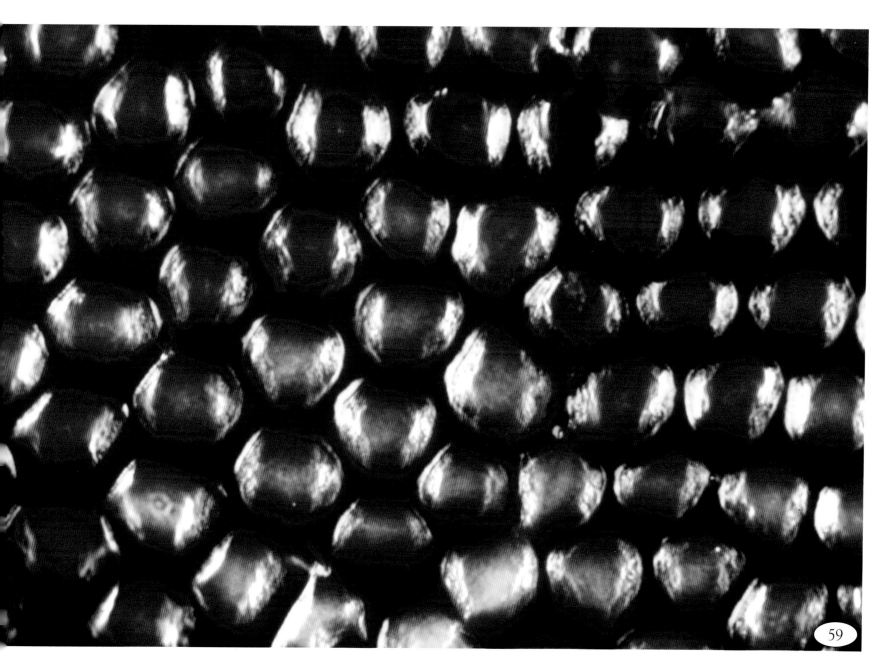

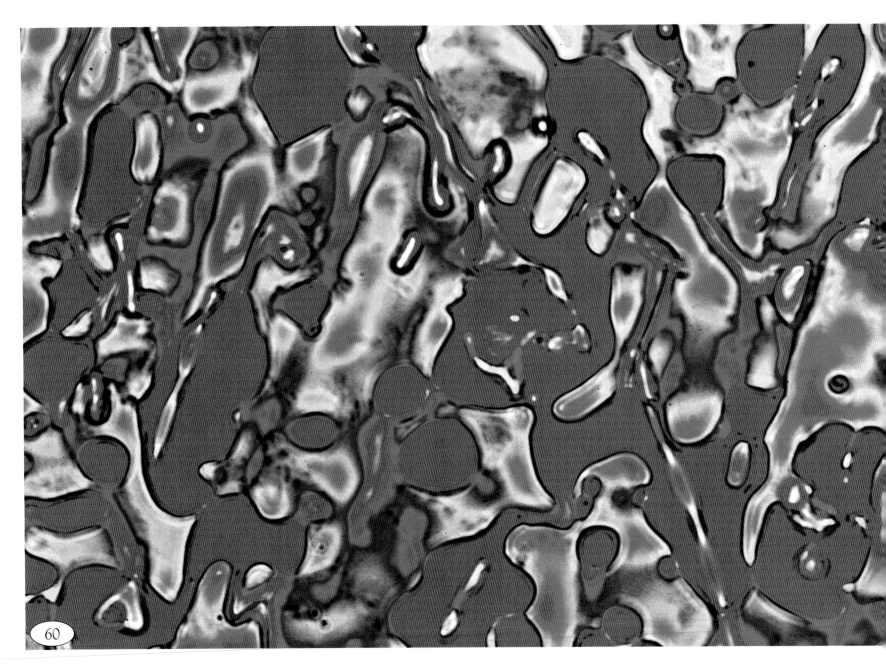
60

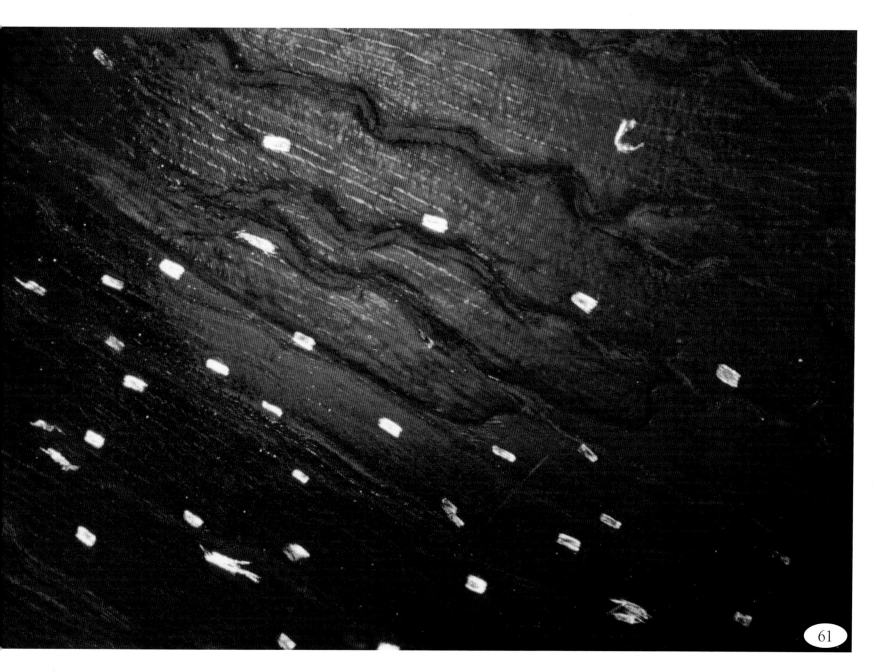

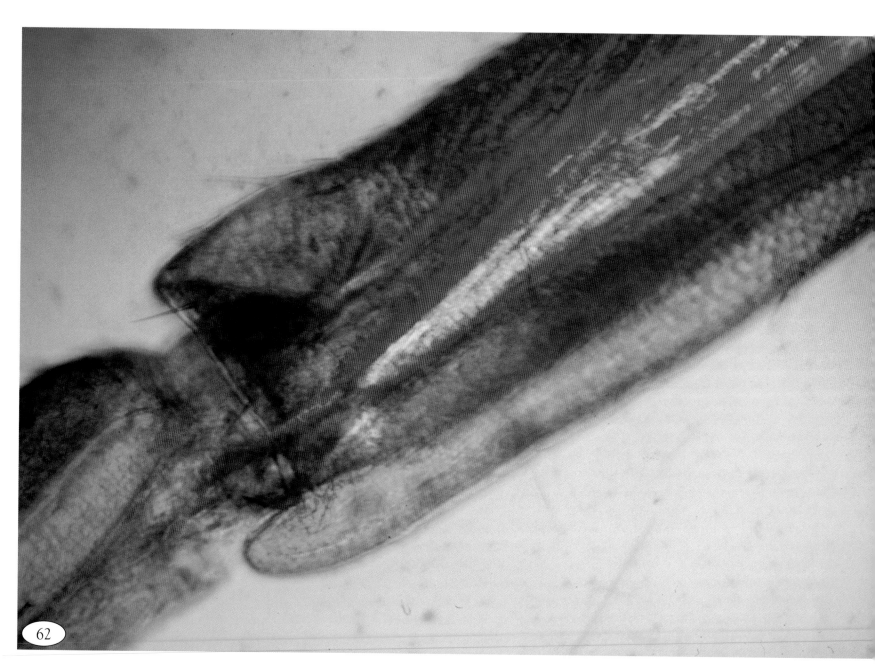

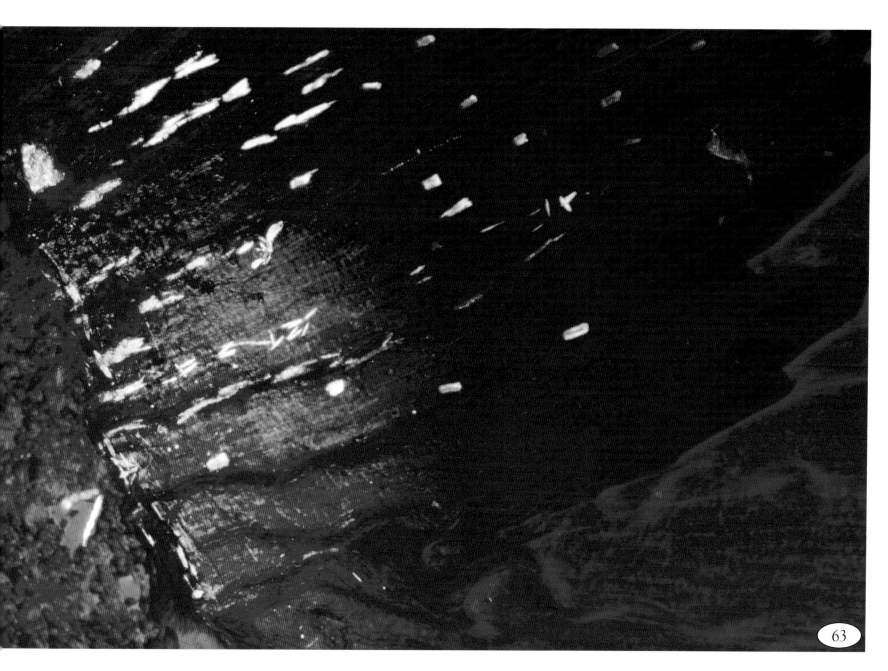

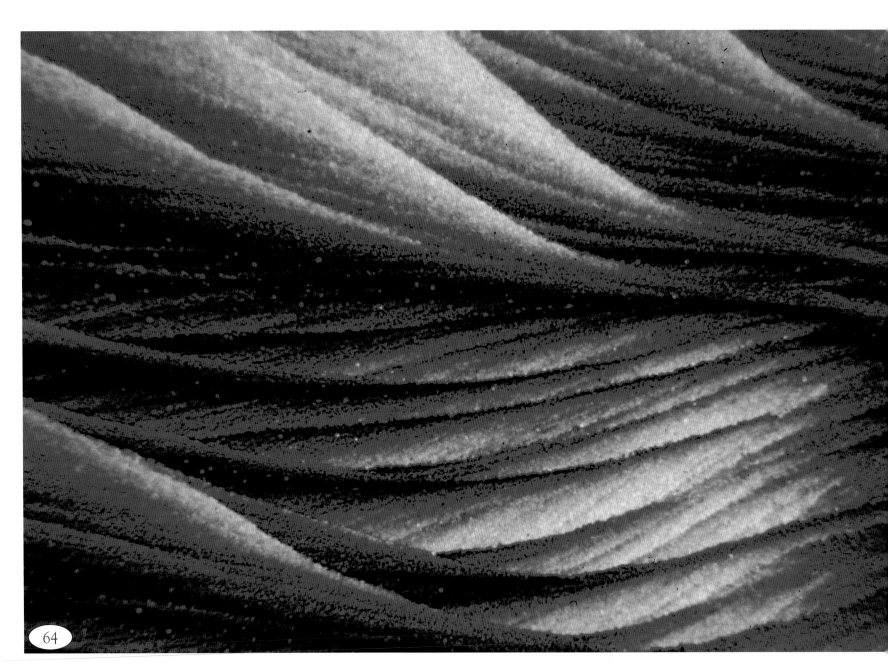

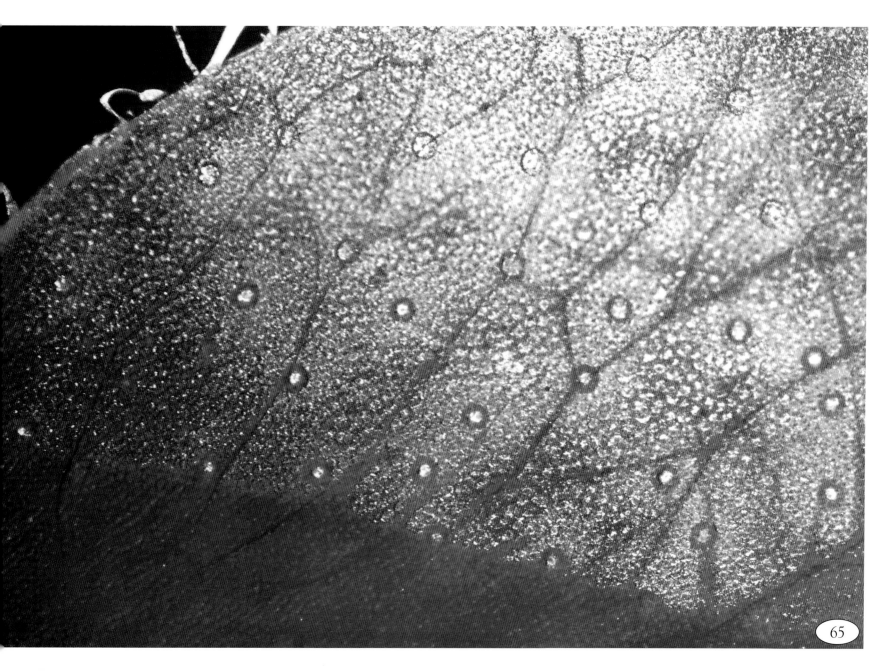

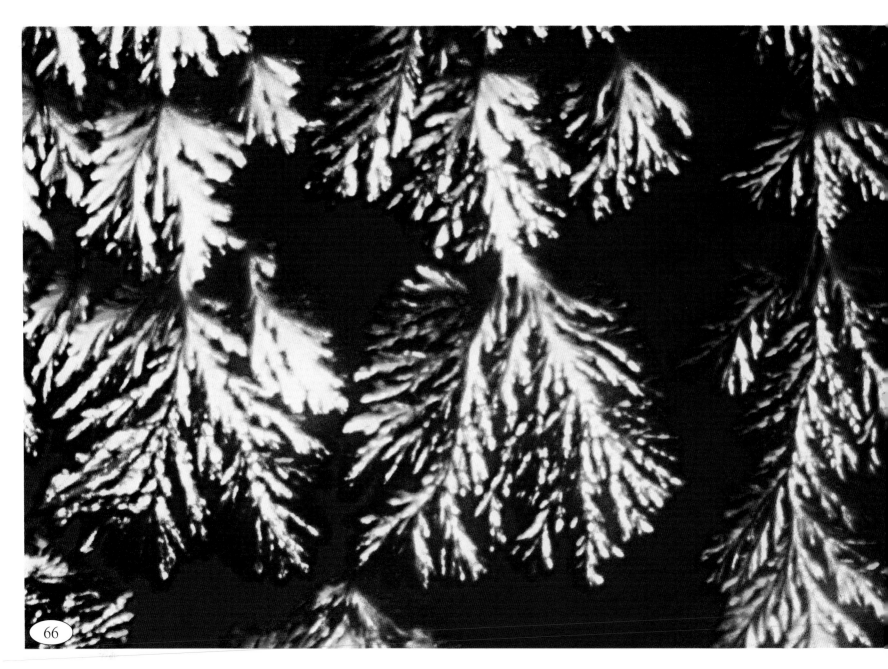

66

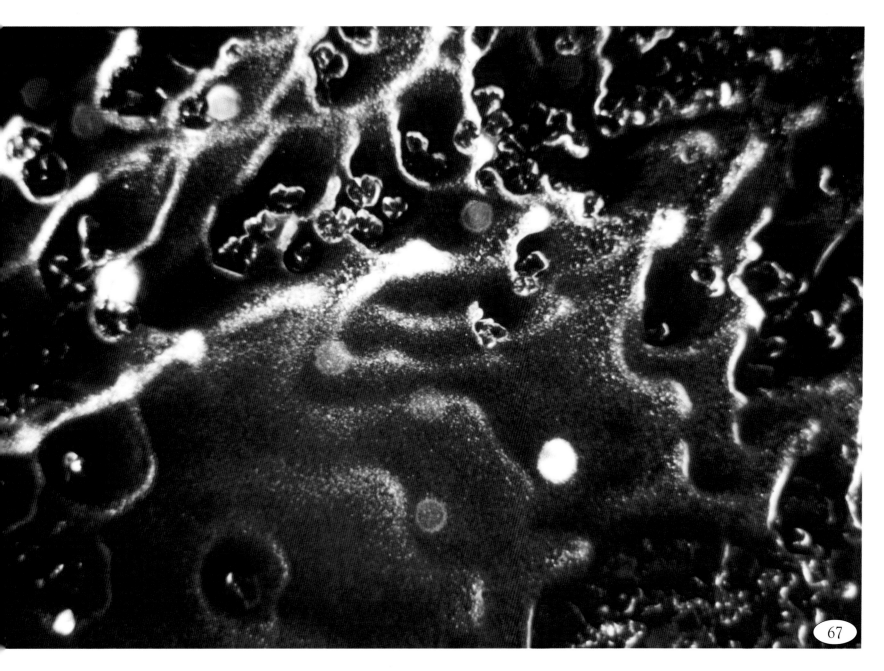

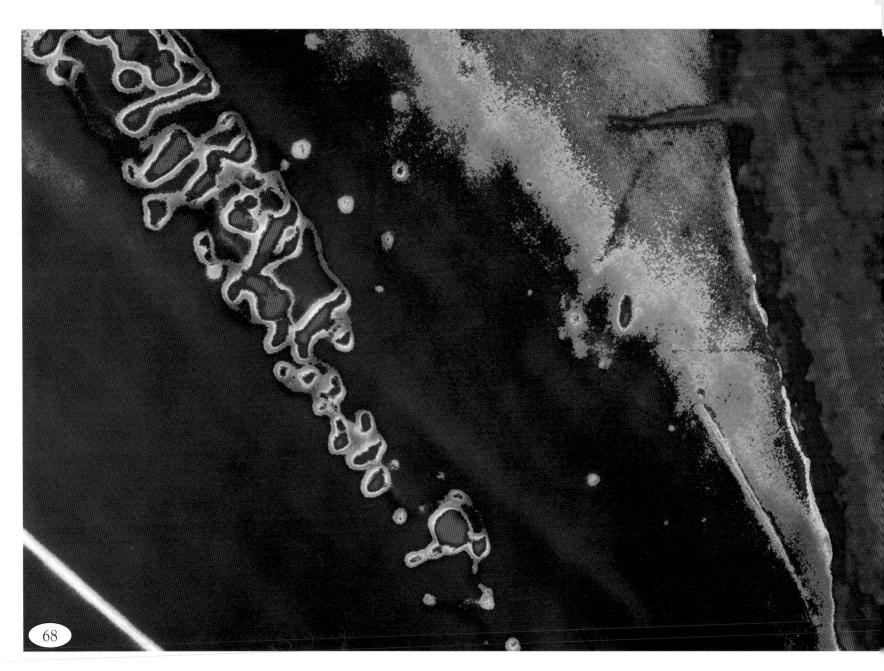

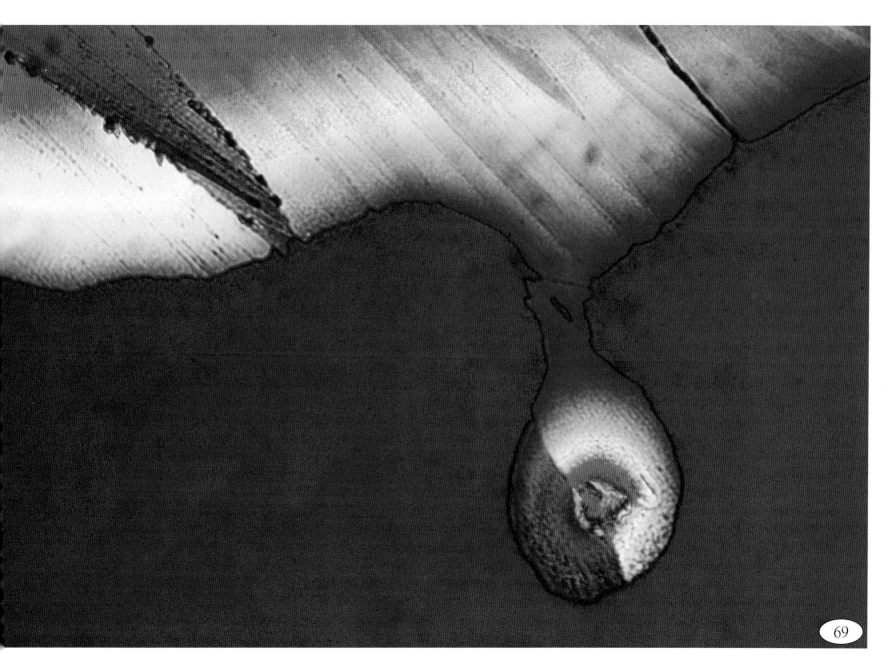

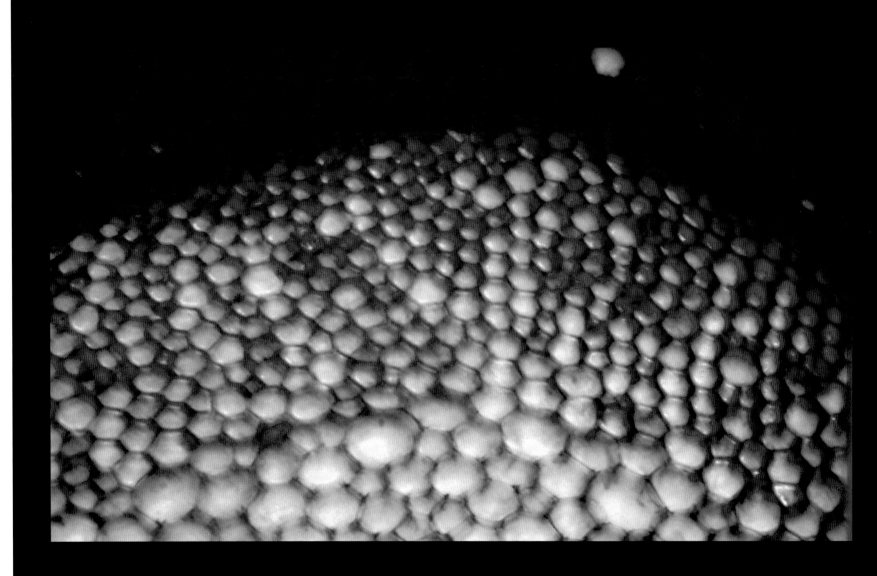

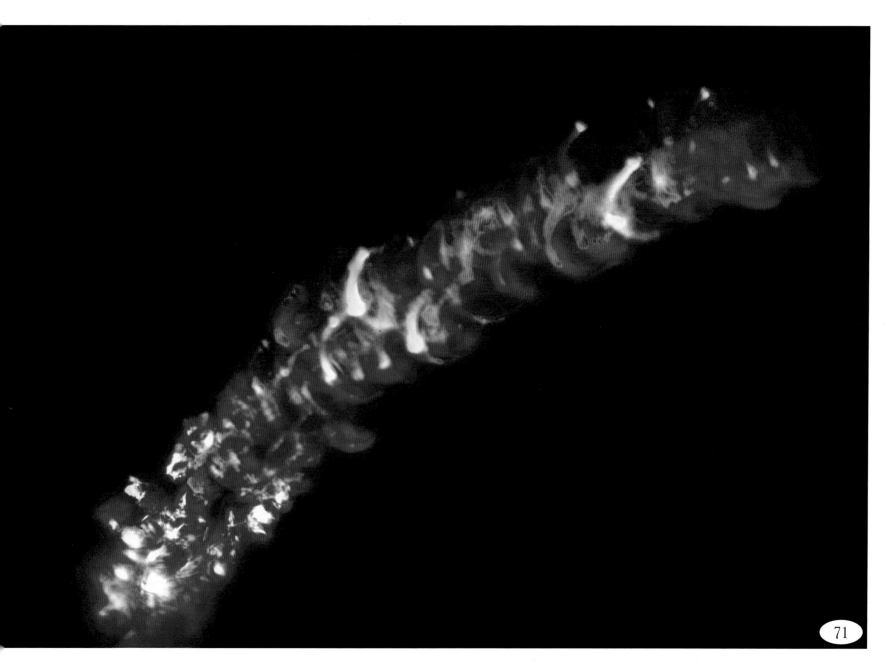

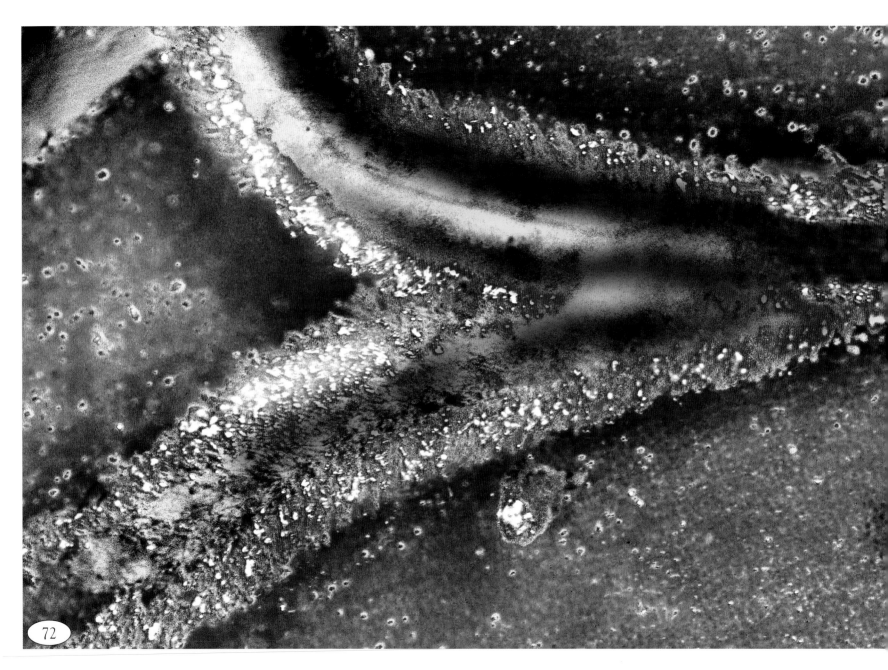

72

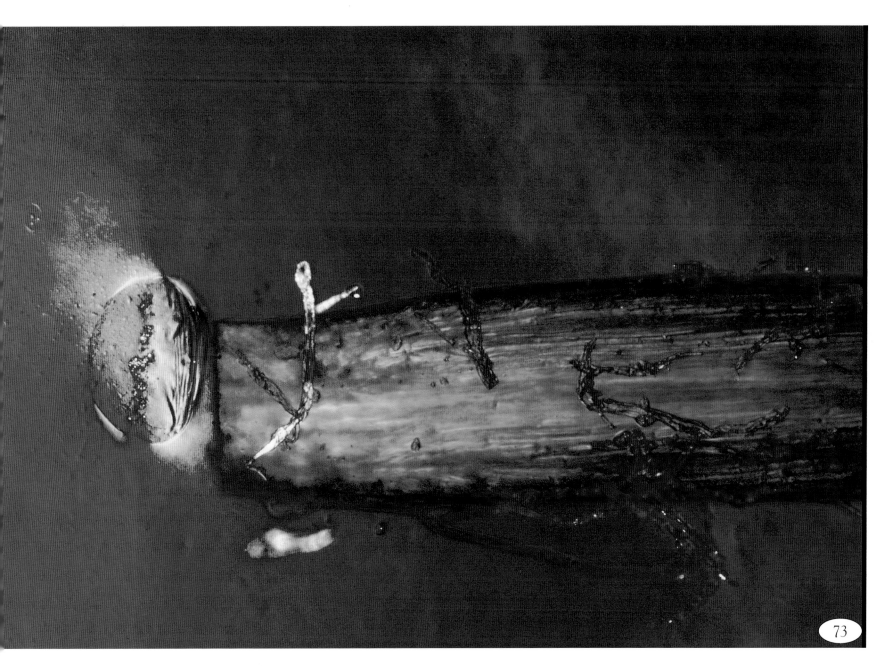

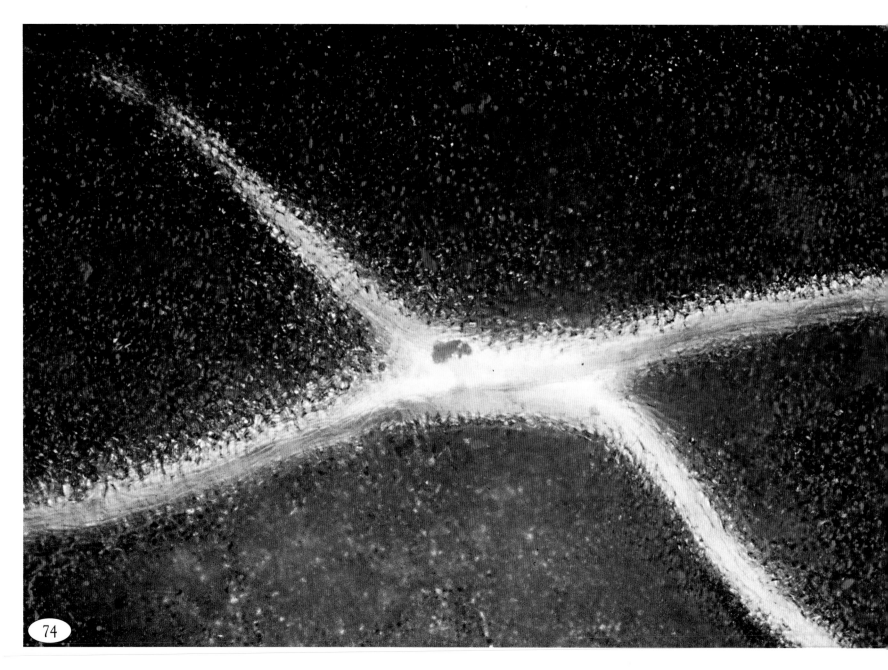

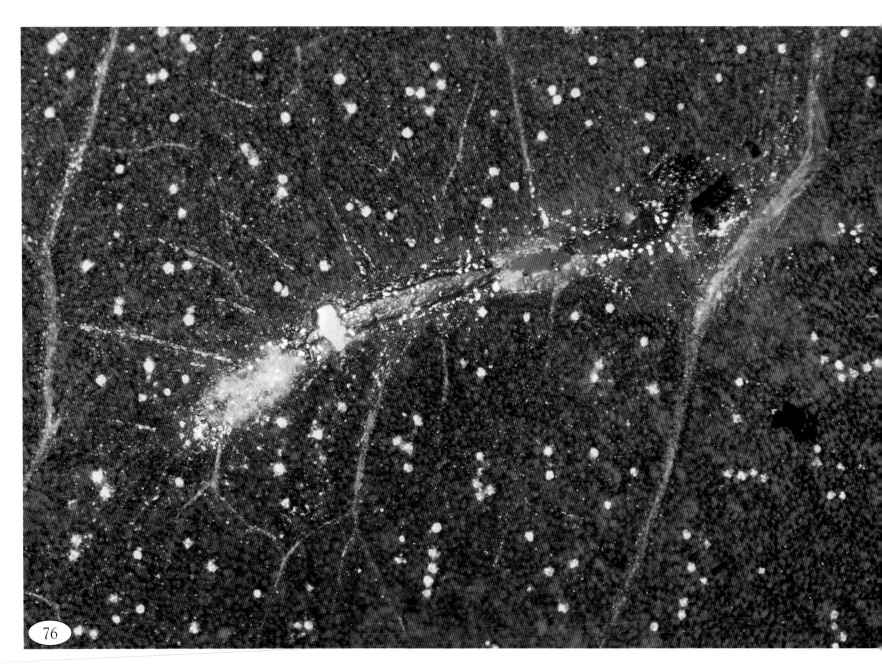

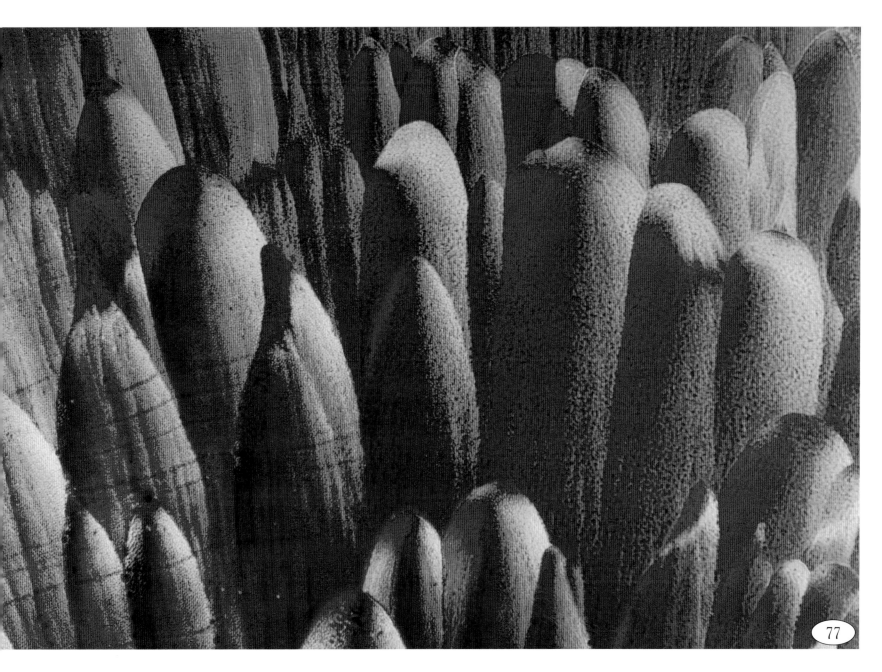

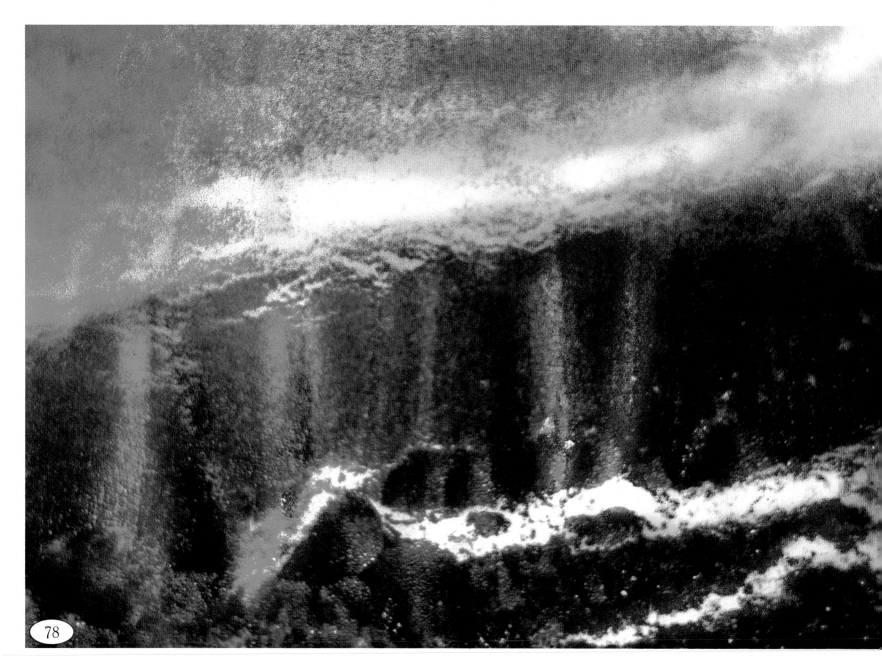

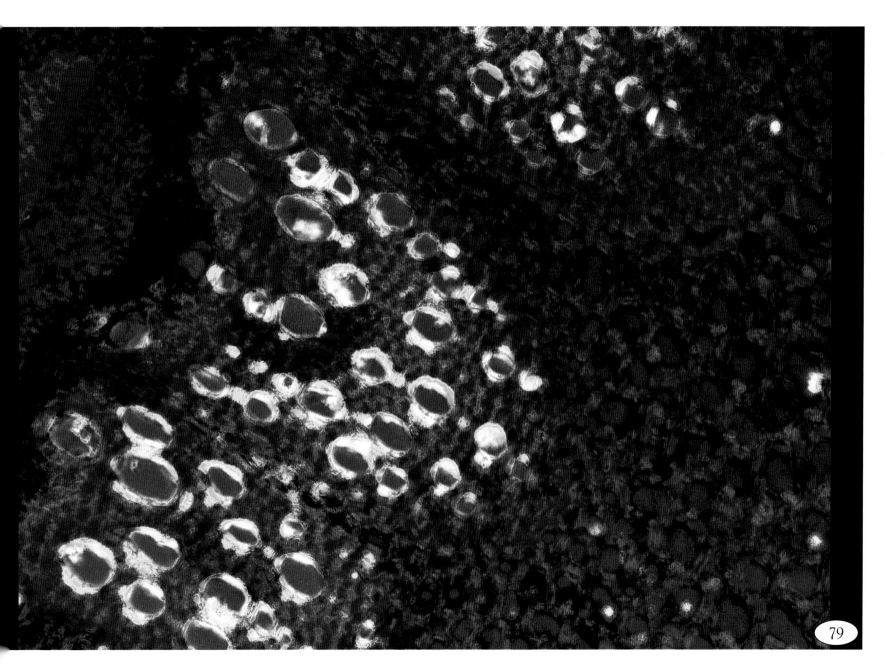

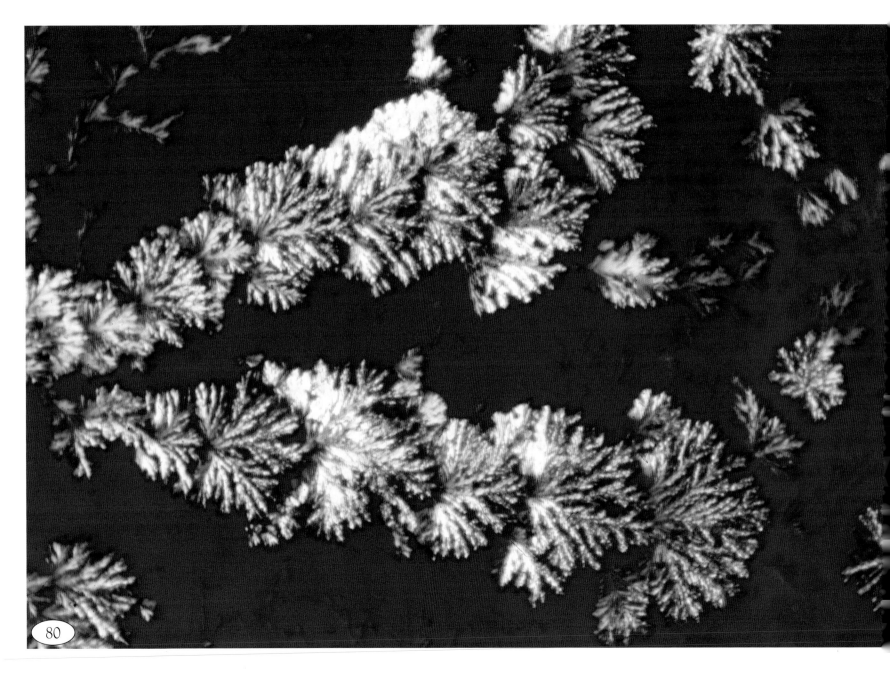

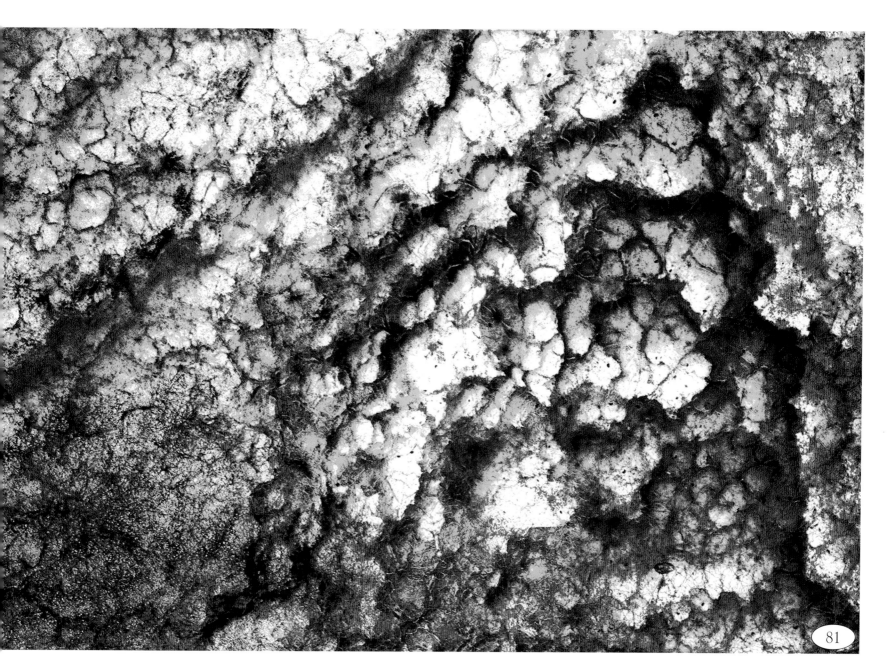

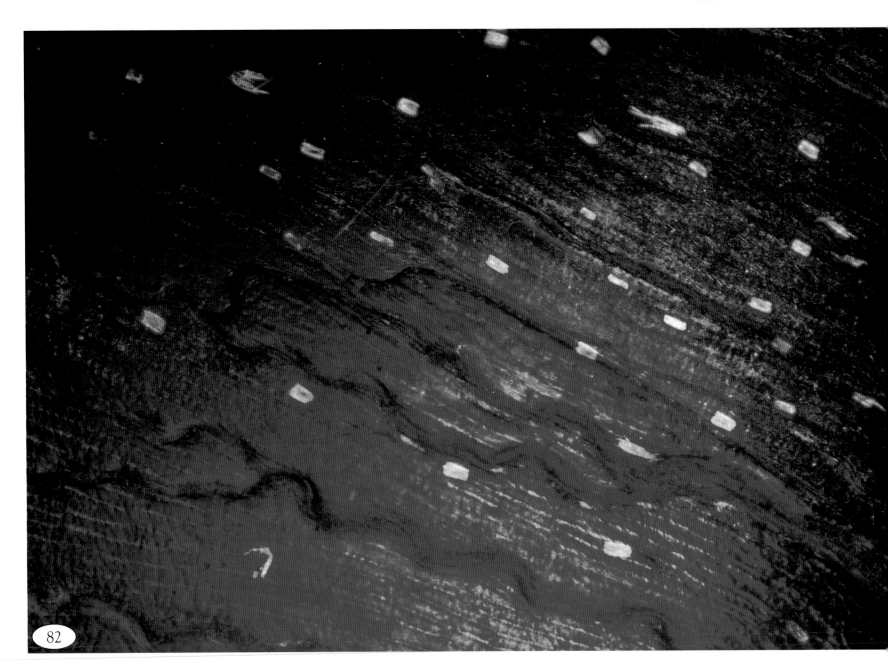

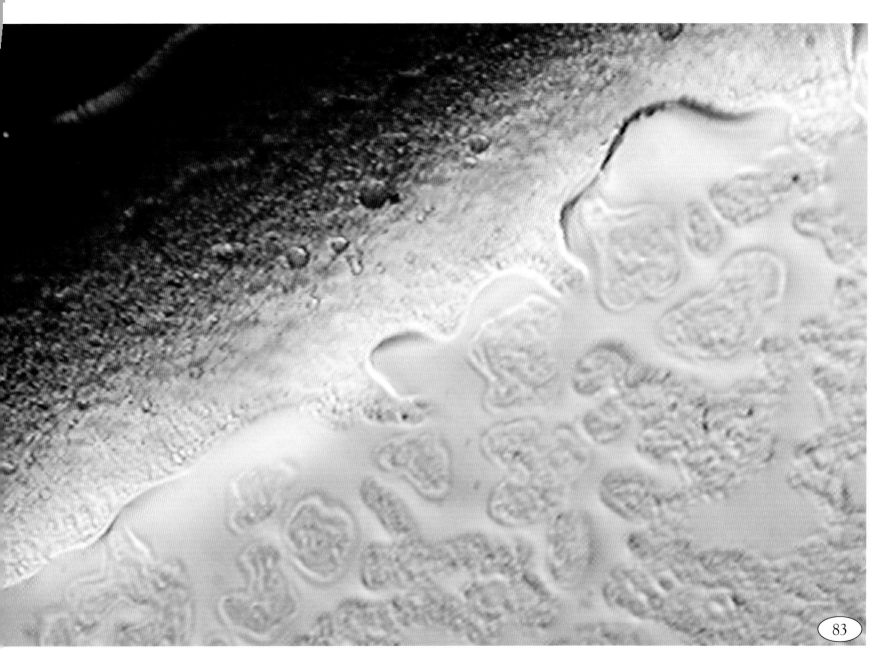

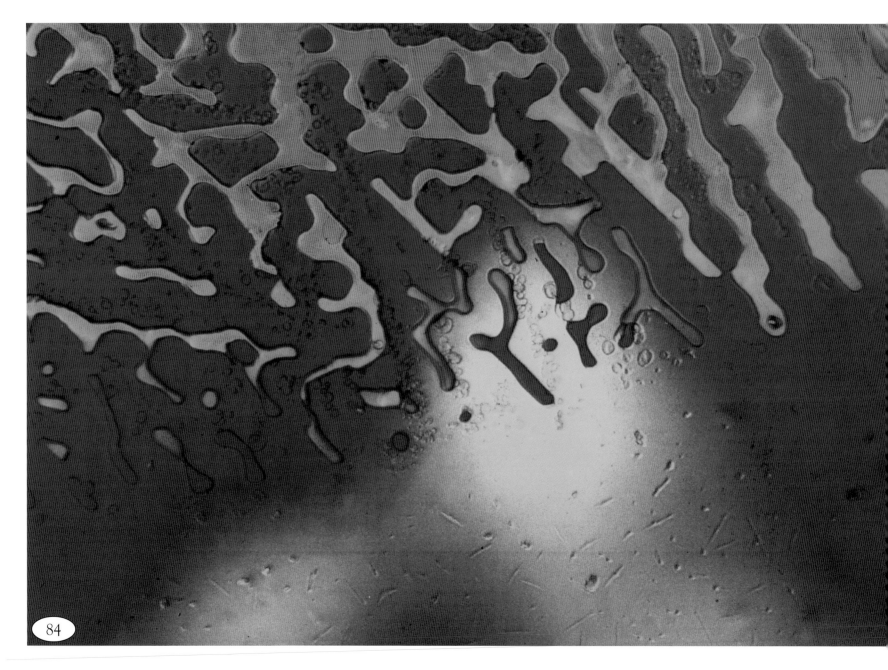

84

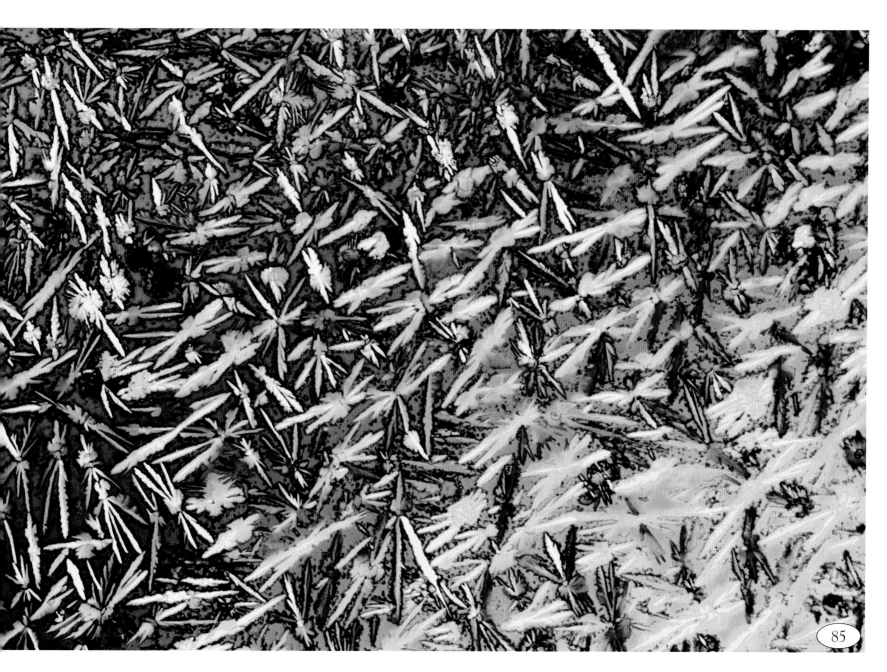

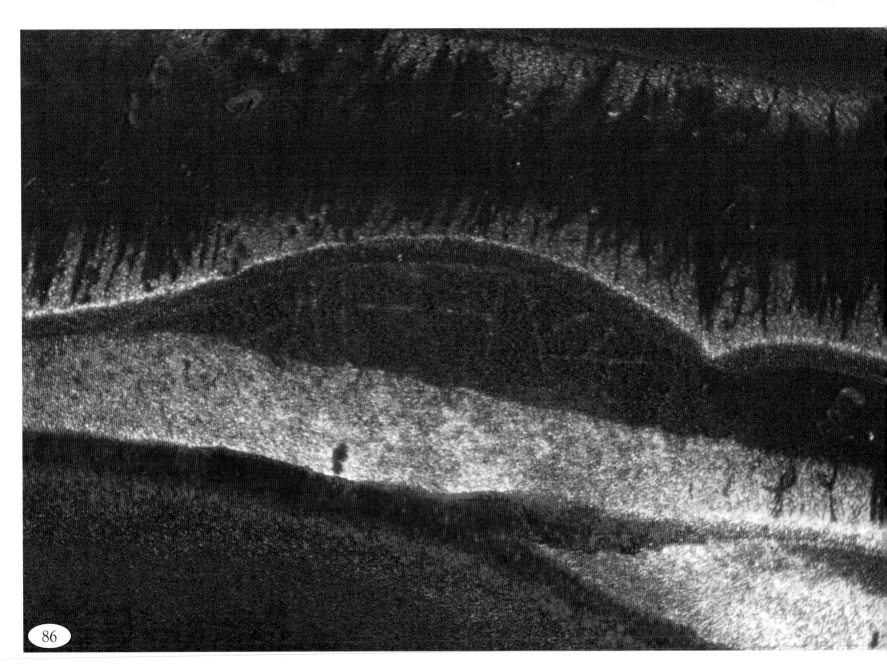

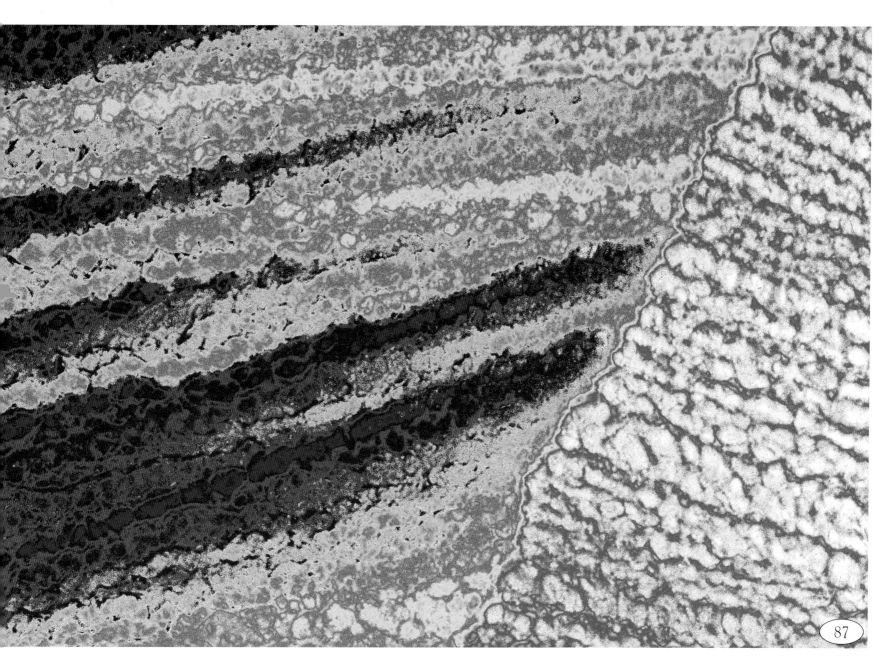

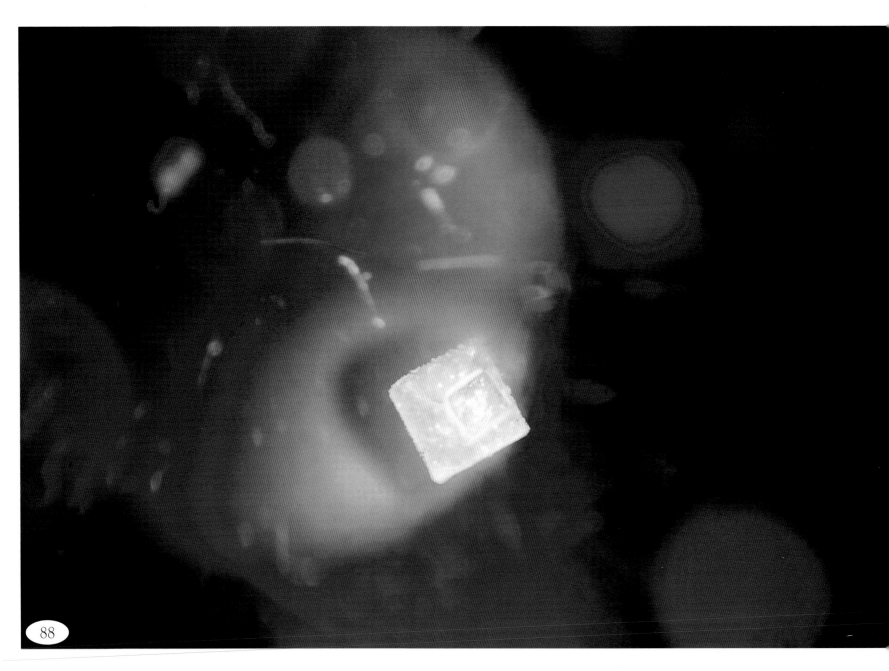

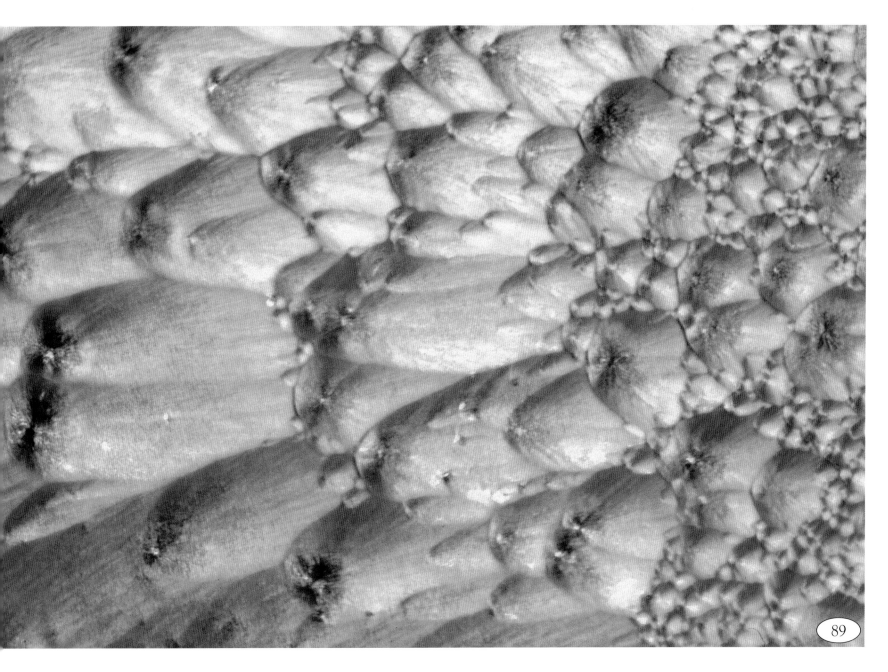

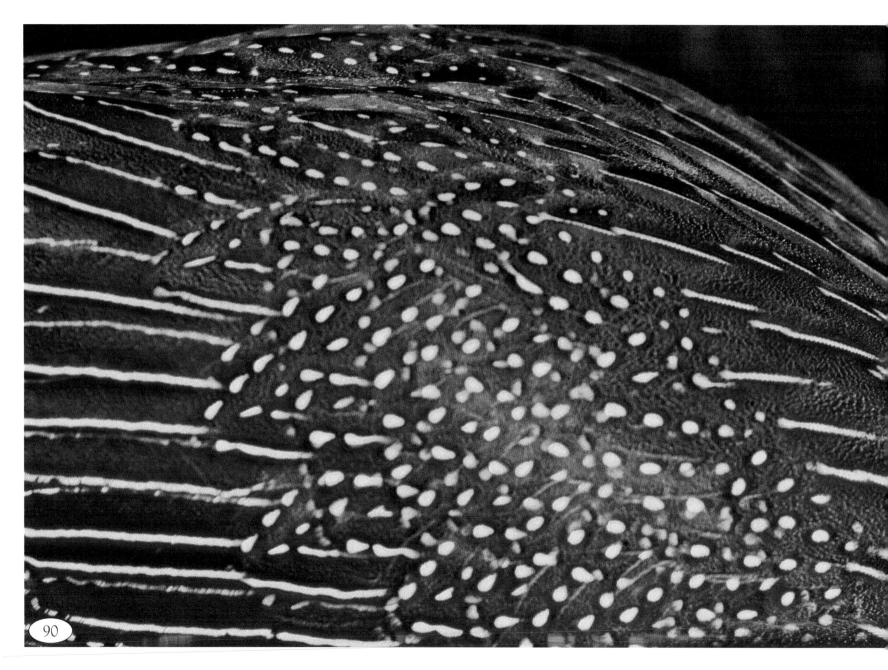

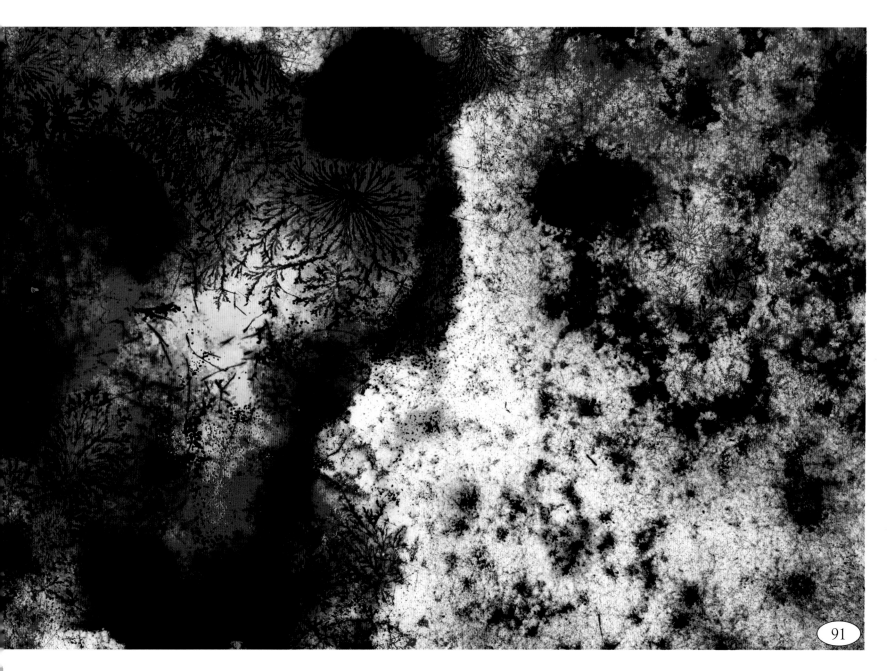

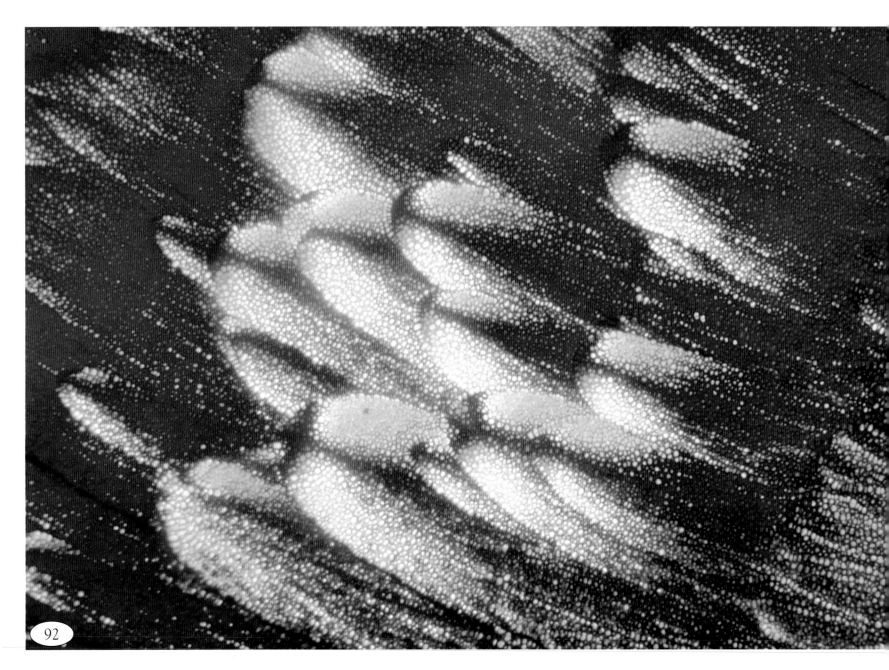

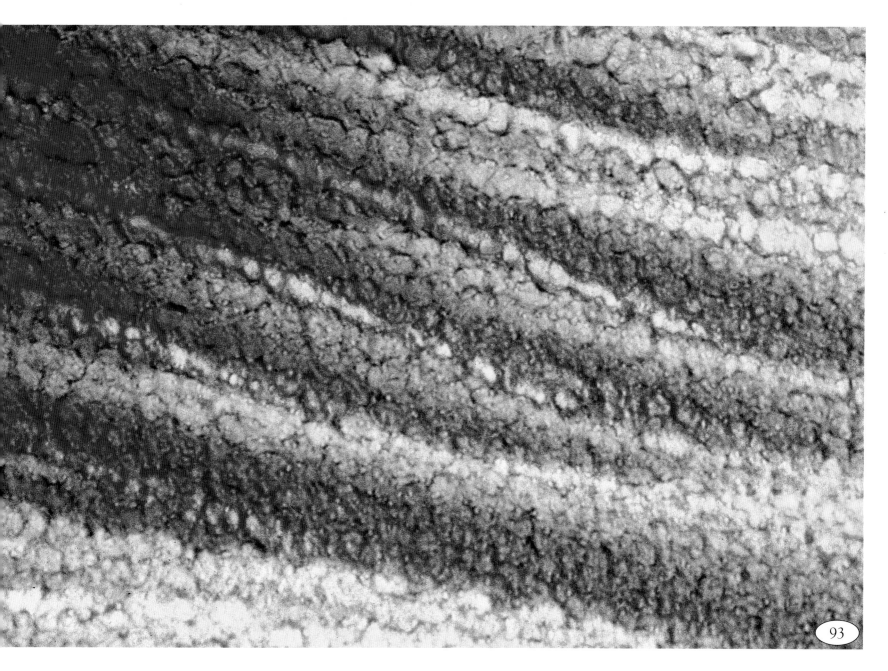

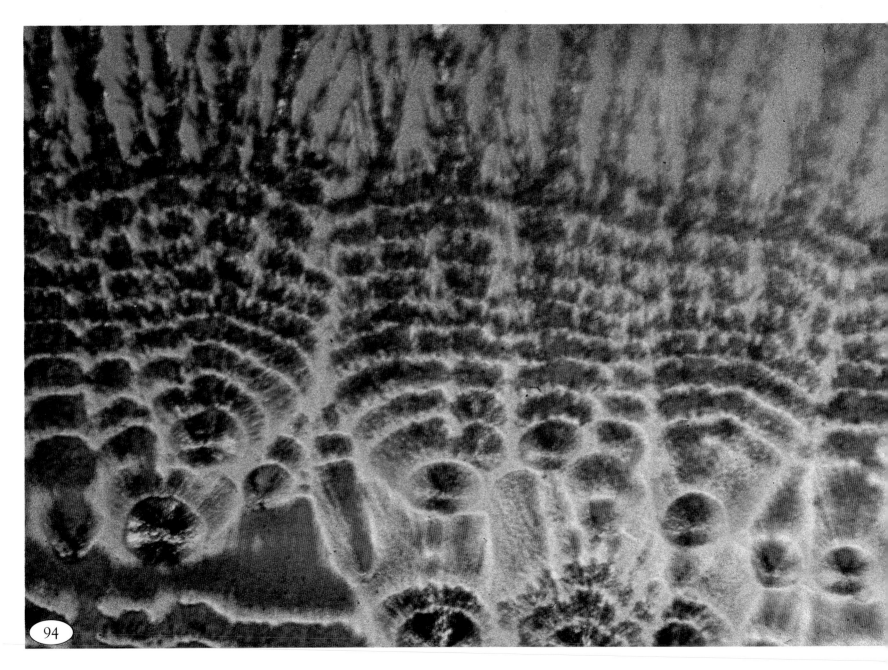

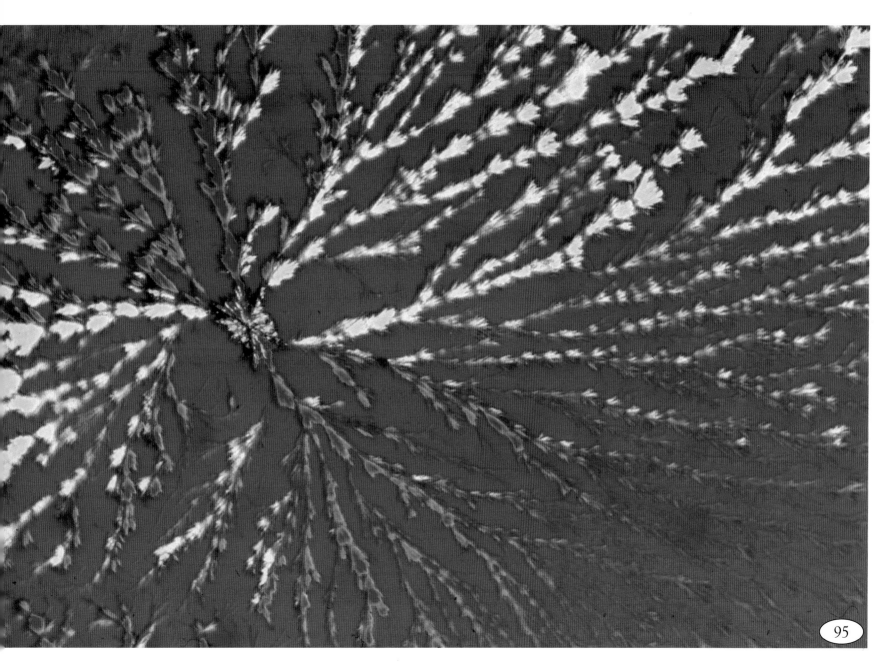

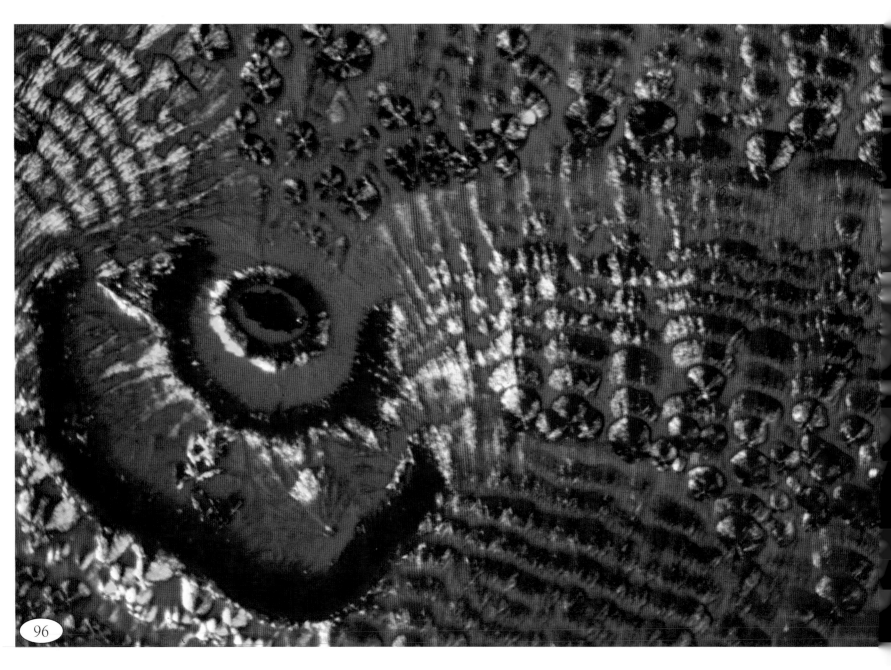

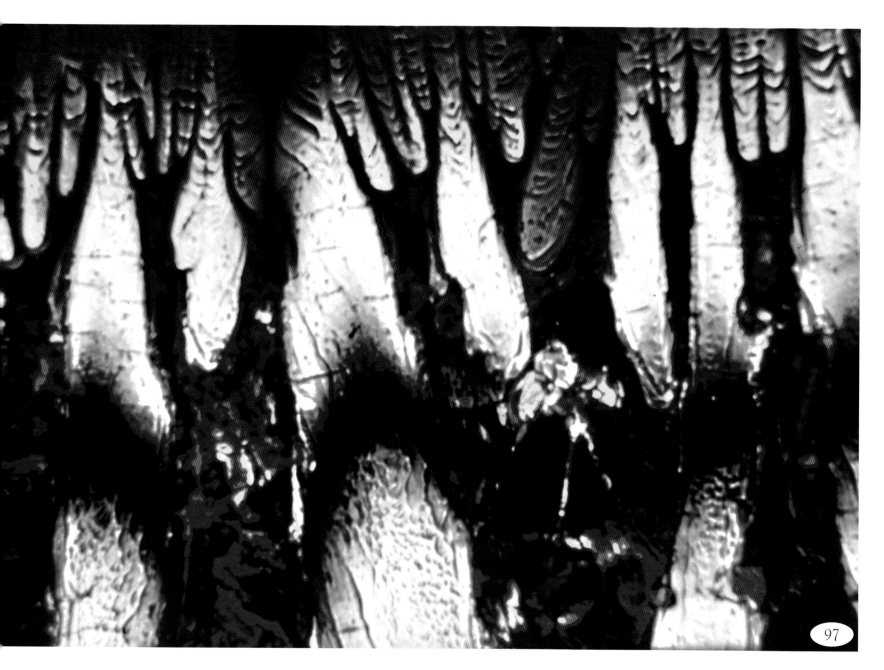

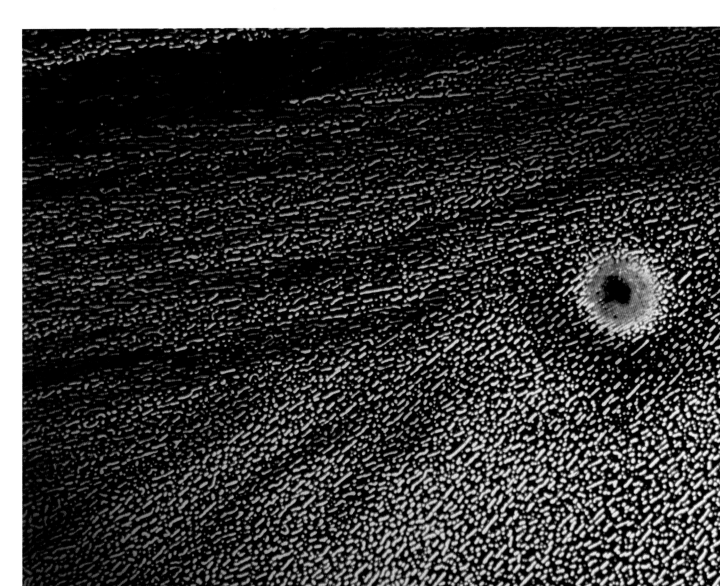

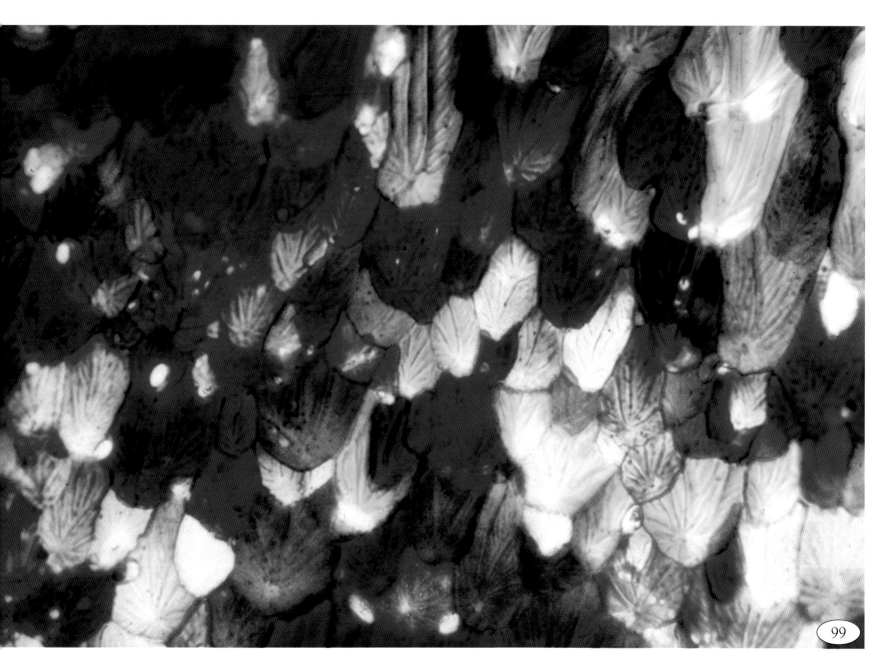

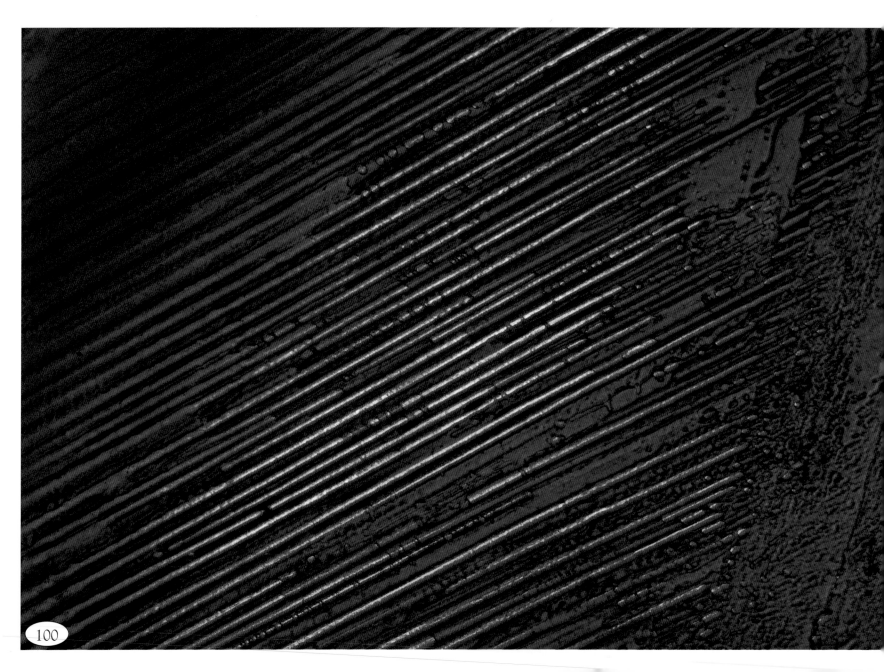

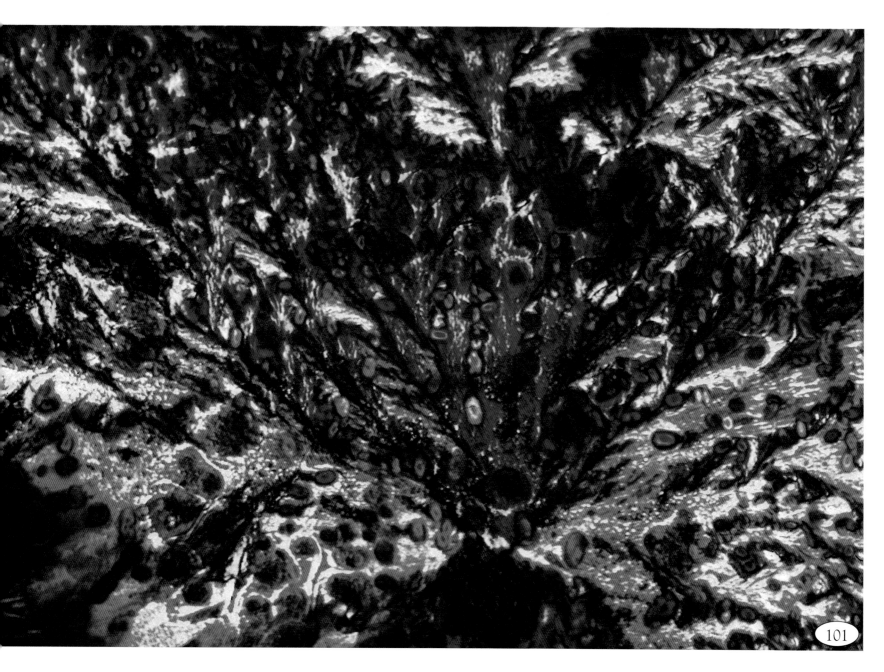

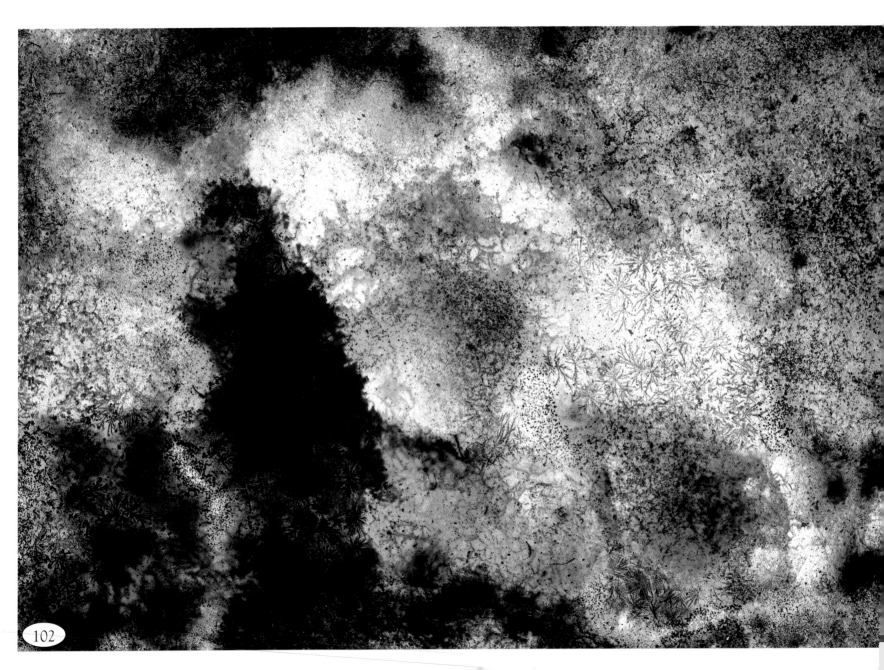

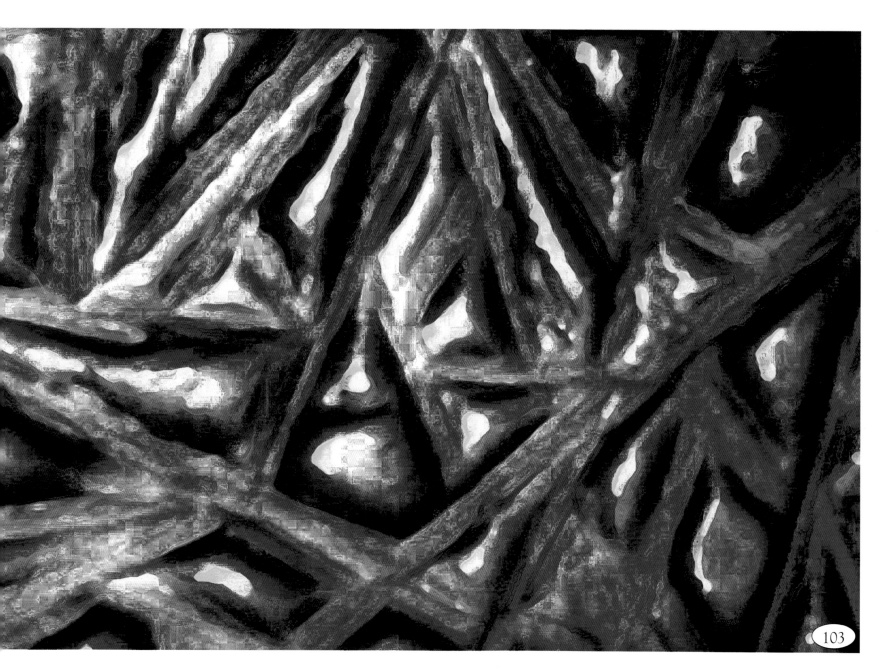

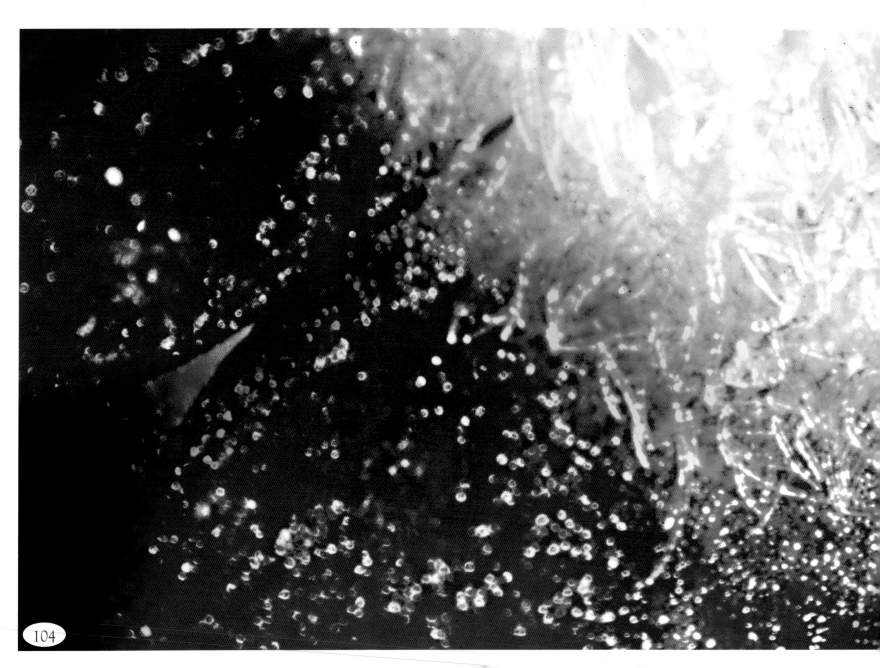

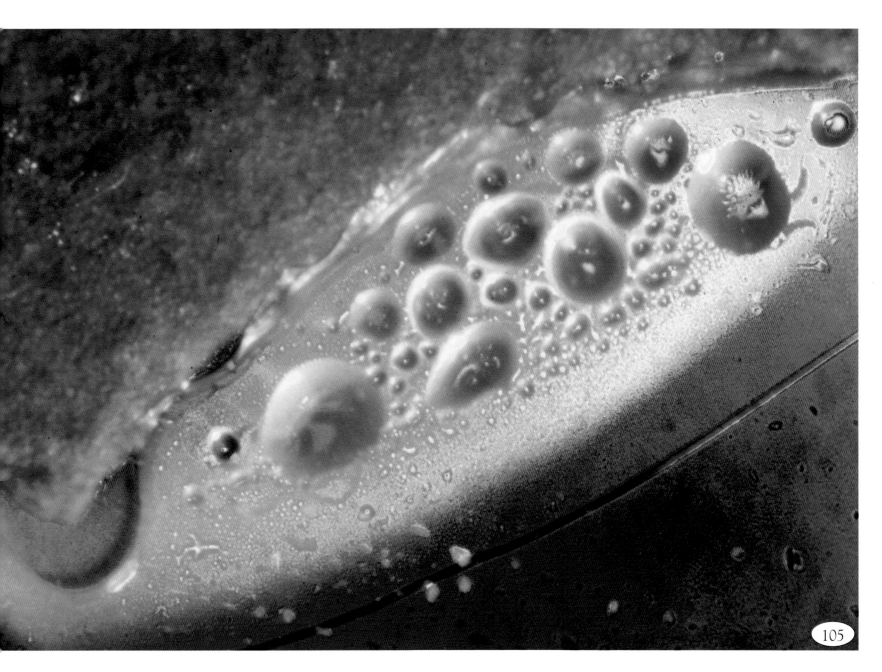

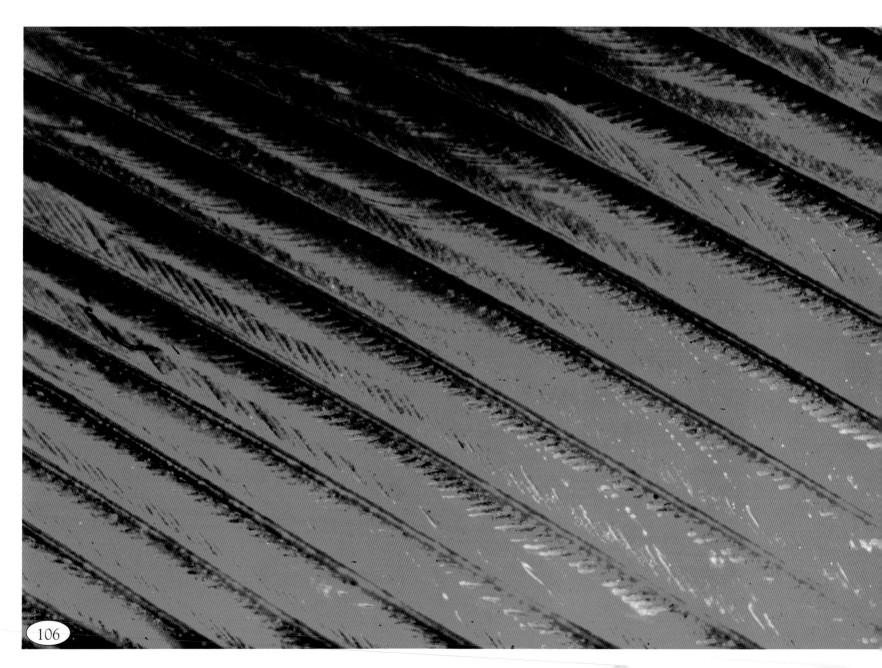

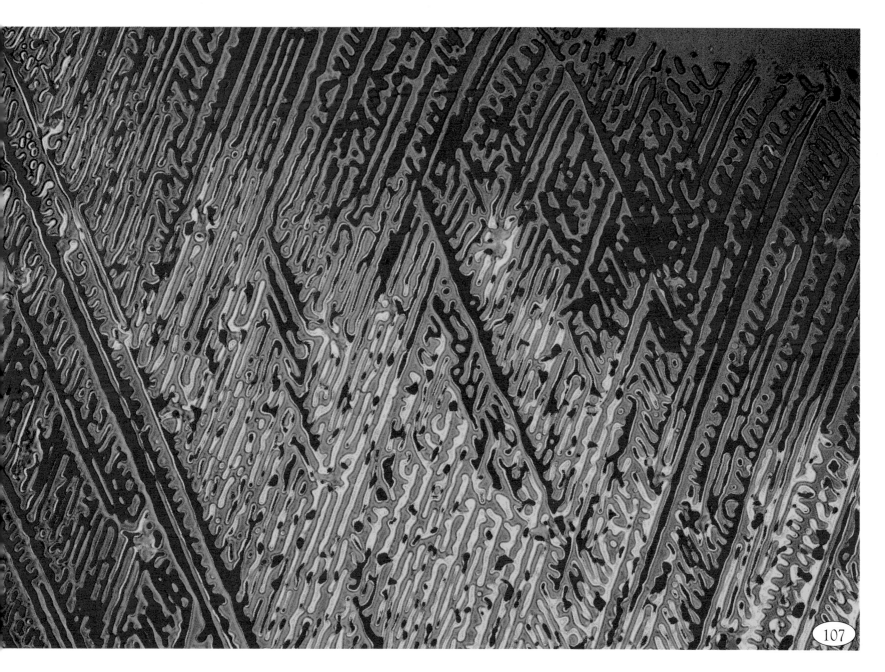

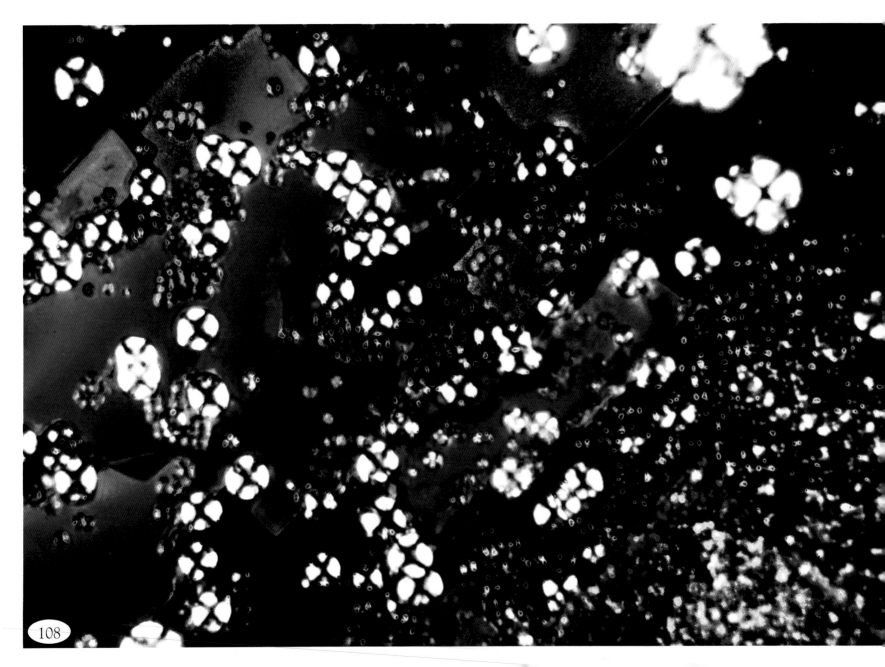

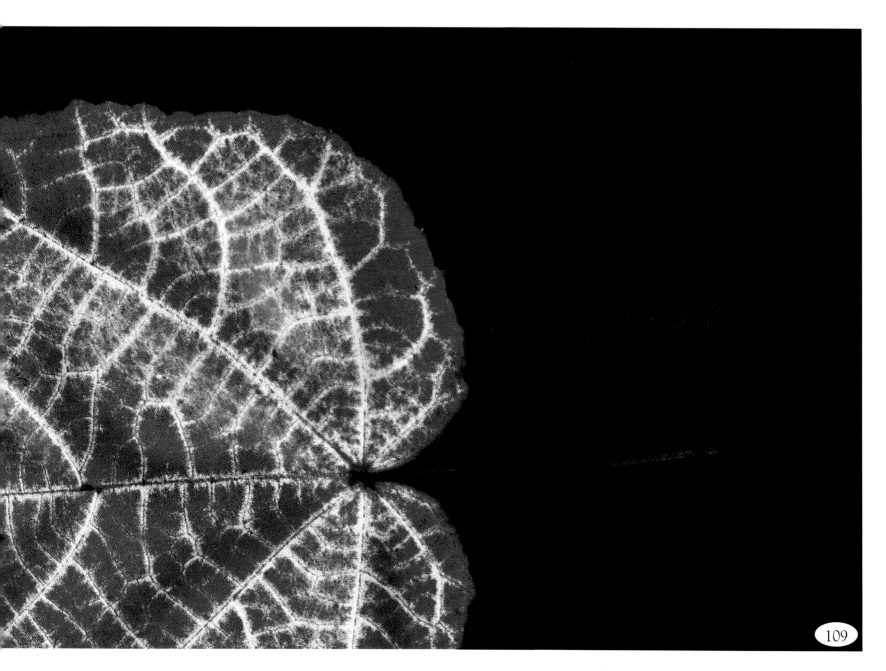

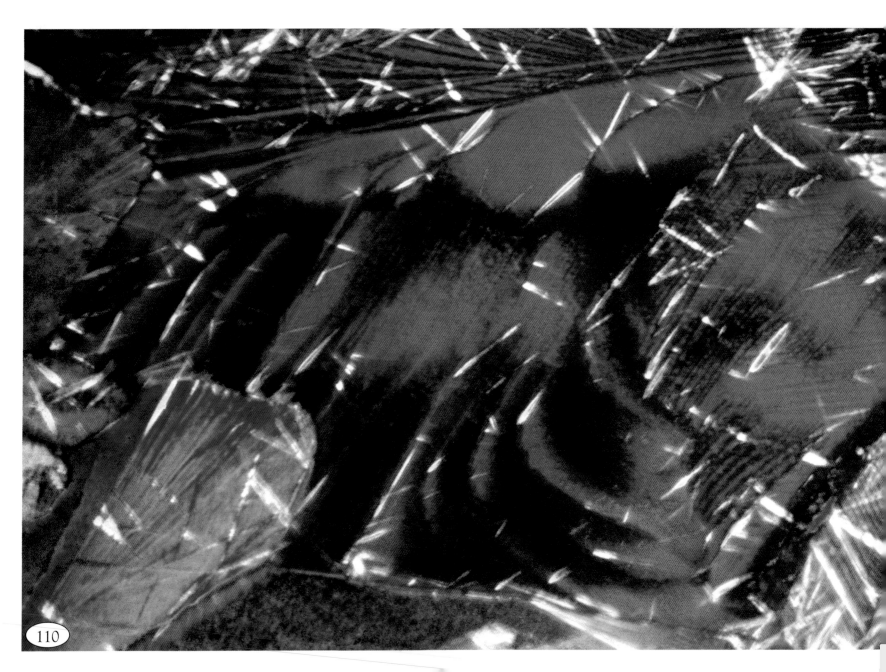

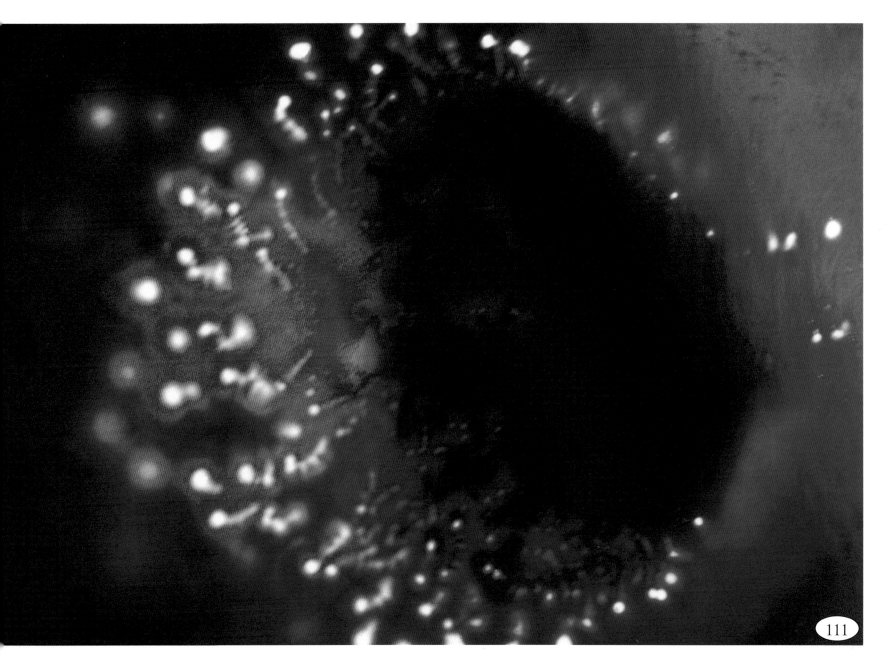

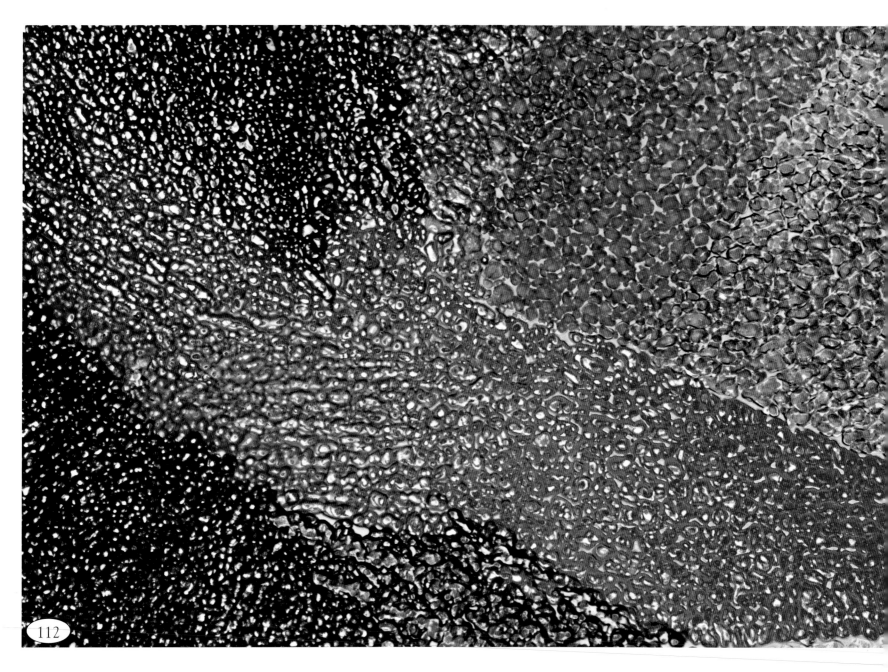

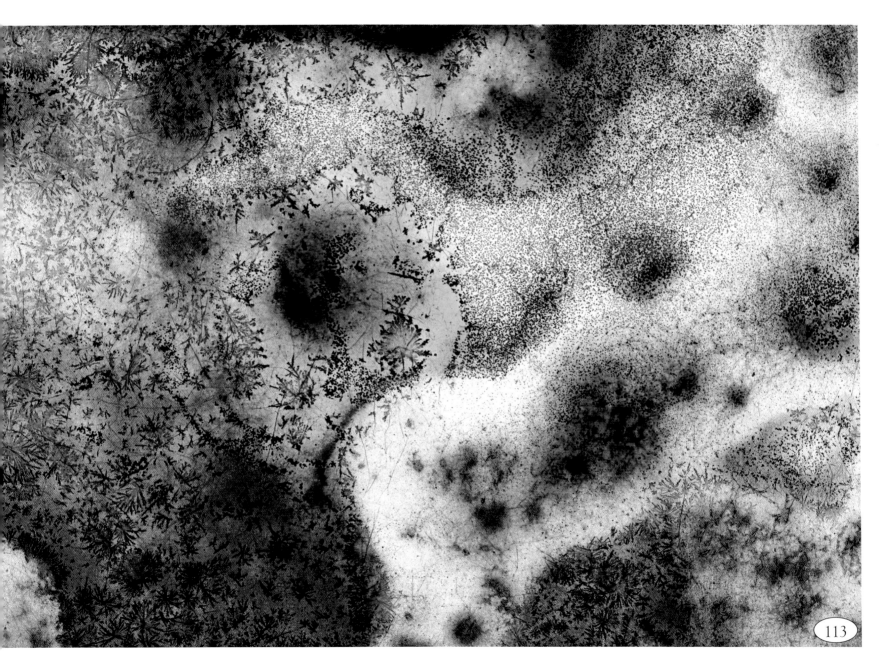

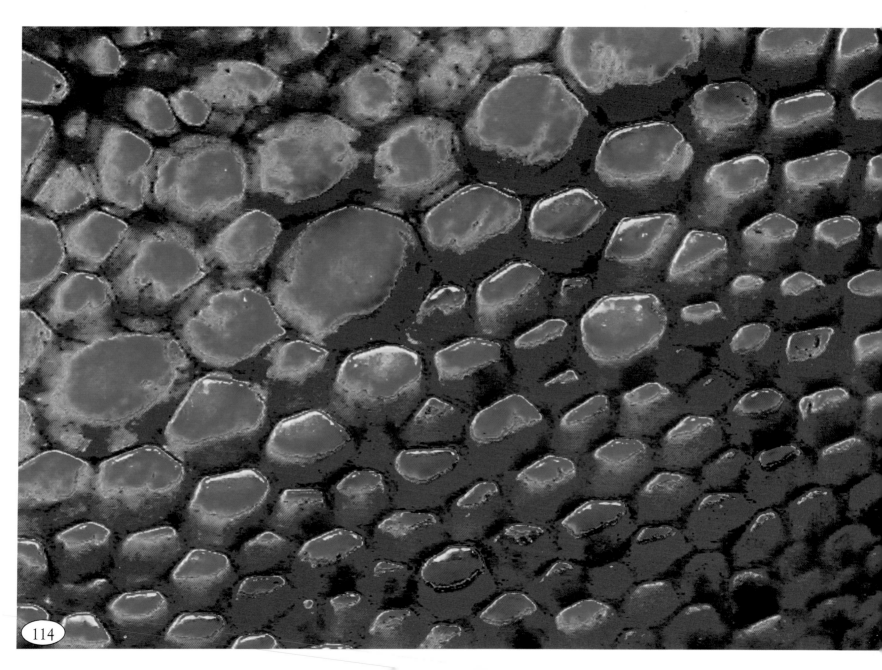

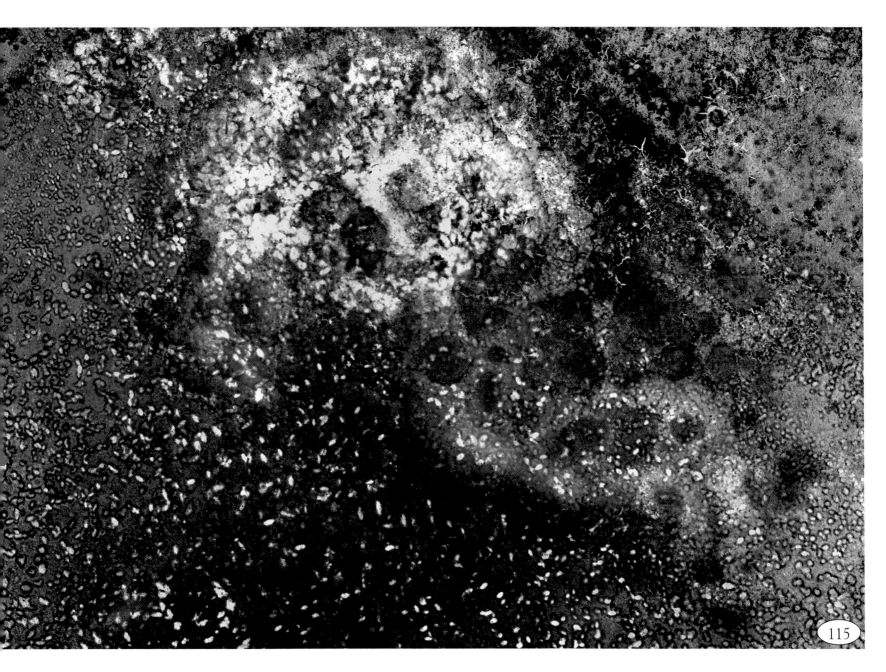

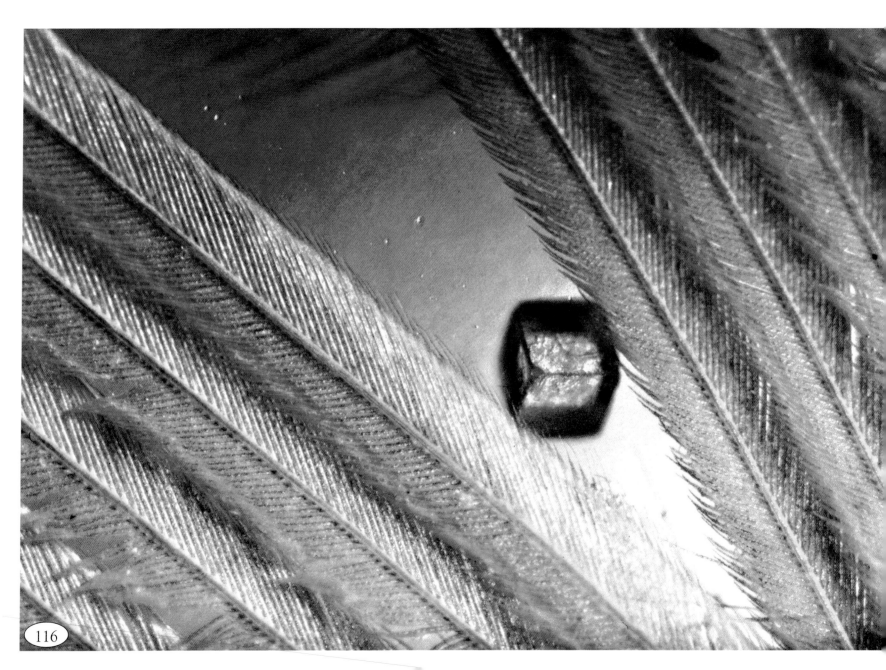

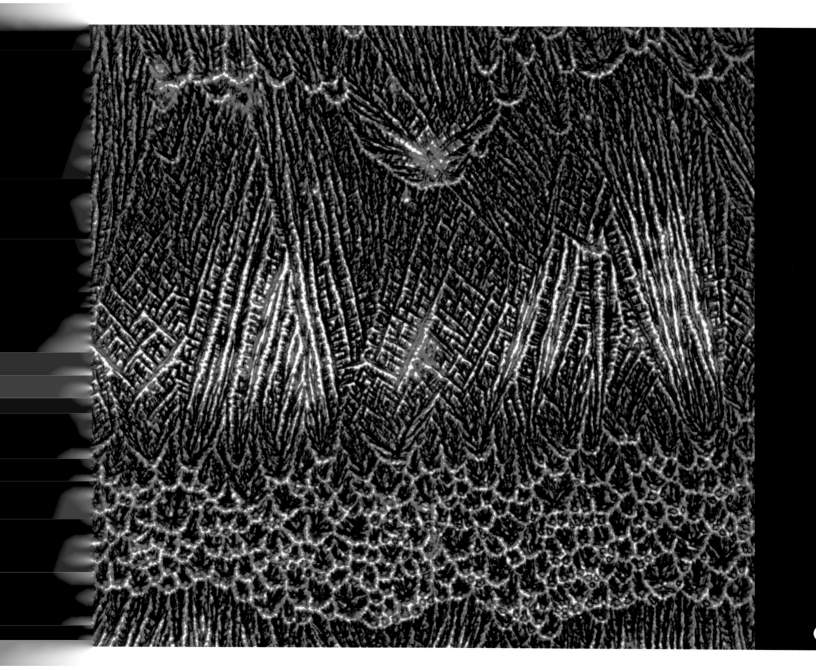

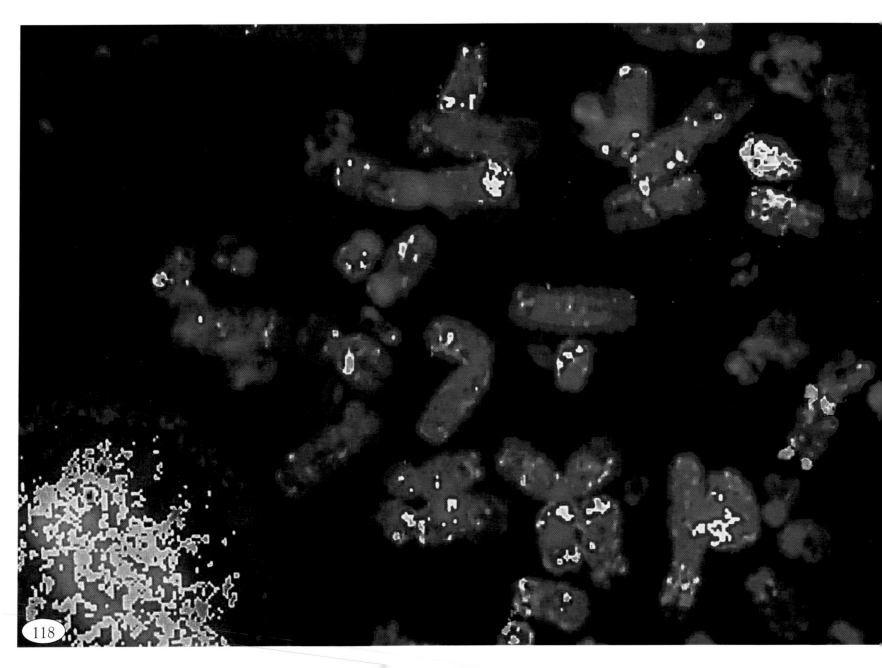

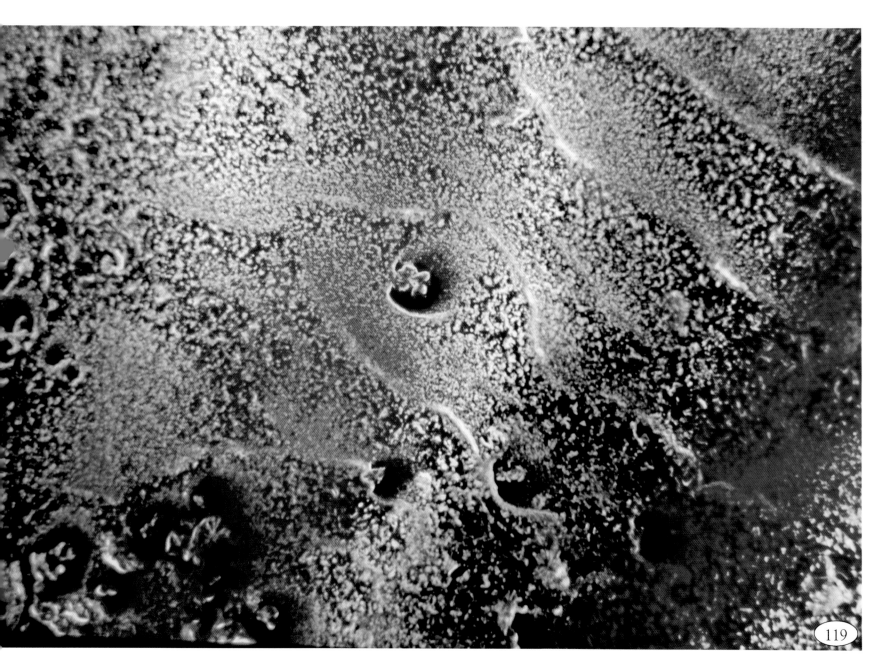

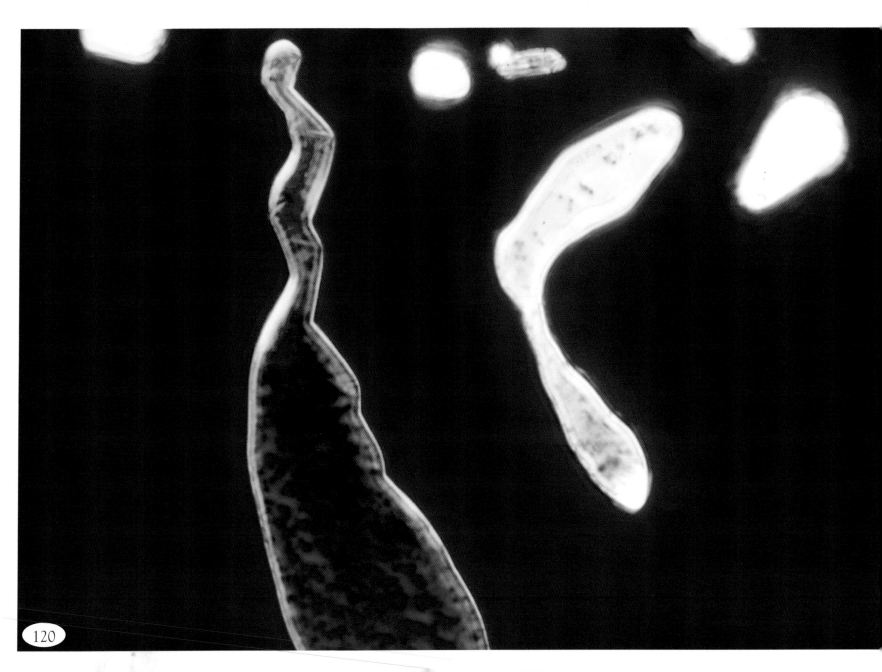

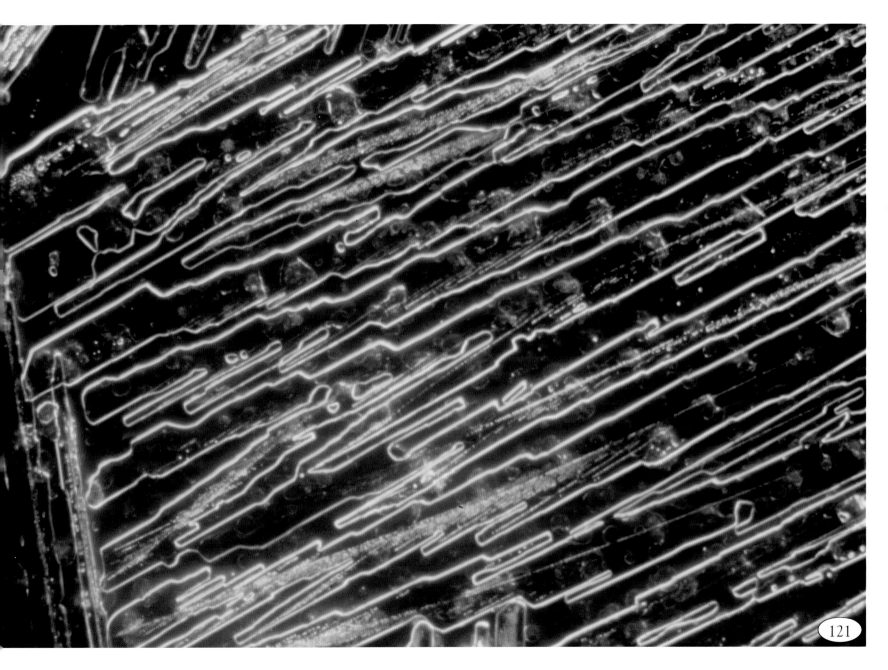
121

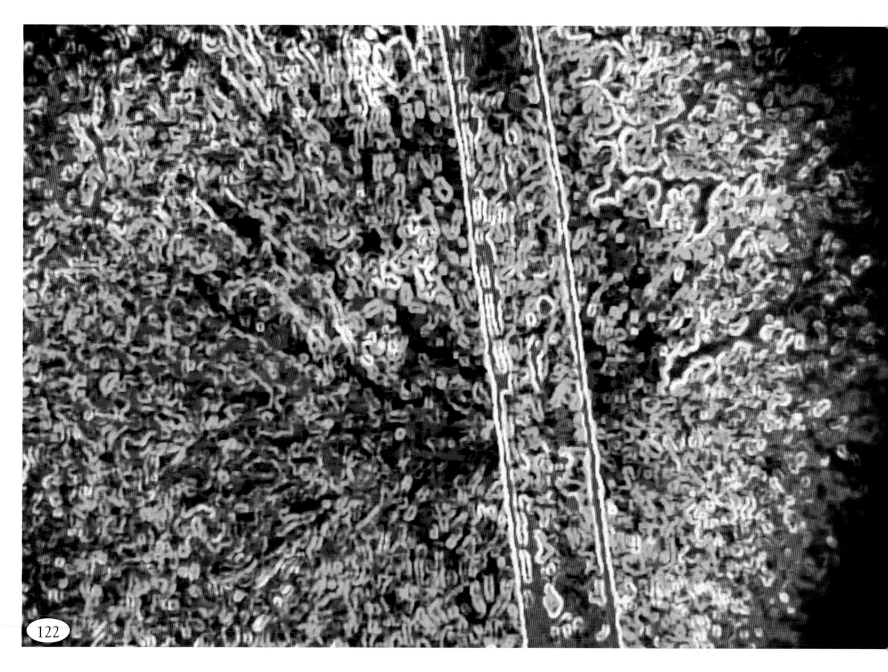

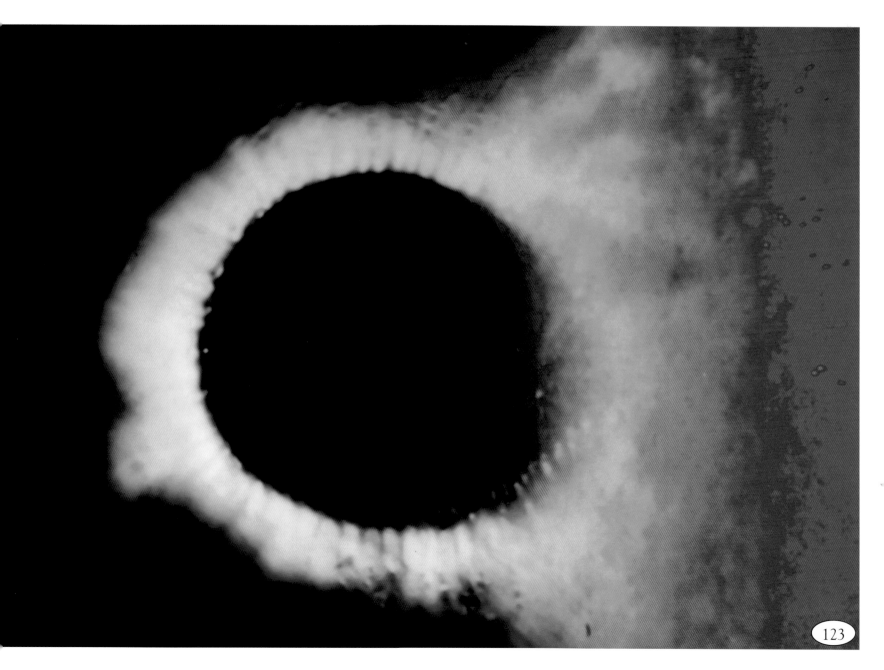

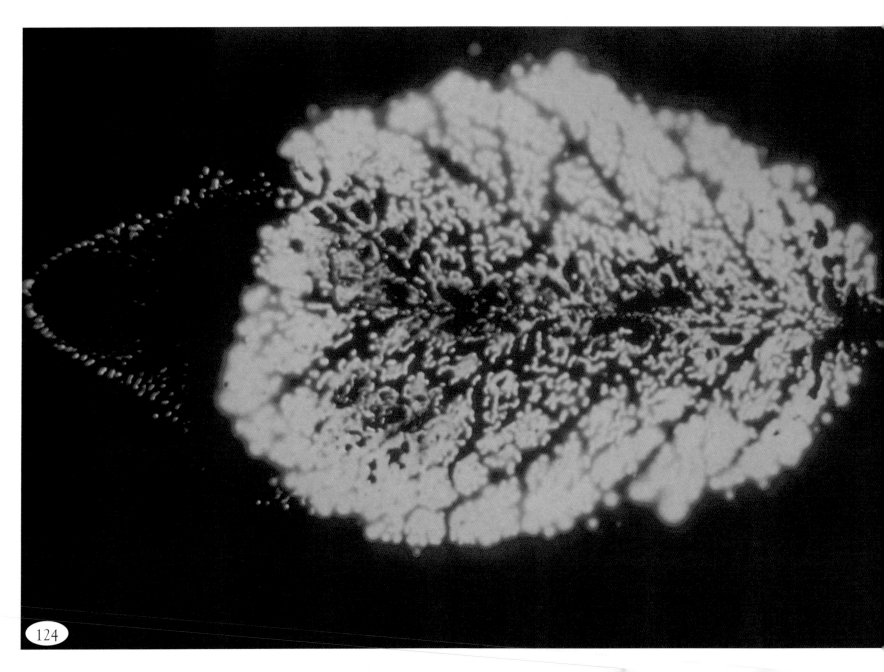

INDEX

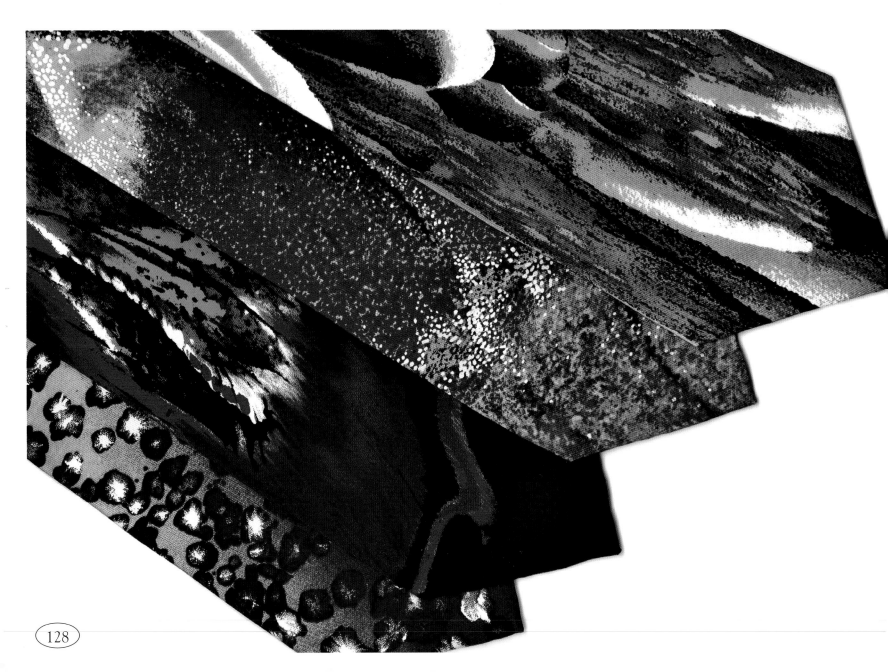

DATE DUE

MAY 07 2018			